IMAGES
of America

DELAWARE FARMING

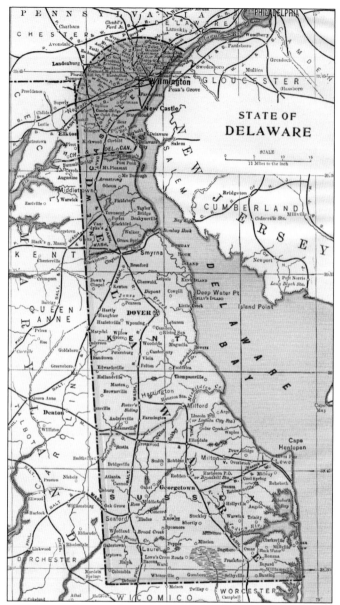

This 1908 map of Delaware depicts the state's three counties: New Castle, Kent, and Sussex. The tidal streams on the Delaware River provided the first linkage for farmers to markets in Philadelphia, New York, and other Eastern cities, as well as grain markets overseas. The map also shows the major railroad lines of the time, giving farmers an important and quicker route to markets. (Courtesy Conrad's History of the State of Delaware.)

ON THE COVER: Teamwork was critical when loading sweet potatoes into the Johnson Potato Storage, Seaford, on October 18, 1922. Curing sweet potatoes for storage at the proper temperatures and humidity allowed farmers to extend the marketing season to the holidays and beyond. The location near the railroad tracks facilitated shipping. Delaware farmers grew sweet potatoes on nearly 10,000 acres in the 1920s, with over 8,000 acres grown in Sussex County. (Courtesy of Delaware State Archives.)

IMAGES
of America

DELAWARE
FARMING

Ed Kee

ARCADIA
PUBLISHING

Published by Arcadia Publishing
Charleston, South Carolina

Printed in the United States of America

Library of Congress Catalog Card Number: 2007921336

For all general information contact Arcadia Publishing at:
Telephone 843-853-2070
Fax 843-853-0044
E-mail sales@arcadiapublishing.com
For customer service and orders:
Toll-Free 1-888-313-2665

Visit us on the Internet at www.arcadiapublishing.com

To all Delaware farmers and those who served them. Special thanks to Halsey G. Knapp, a great farmer who showed me the way.

CONTENTS

ACKNOWLEDGMENTS

The staff at the Delaware State Archives is always helpful and pleasant. The archives is a remarkable source for all things Delaware. Deb Wool at the Delaware Agricultural Museum and Village was also very gracious in sharing the museum's photograph collection. Heather Clewell, Maggie Lidz, and Emily Guthrie at the Winterthur Museum and Library were very cooperative, as always.

I wish to provide a special expression of gratitude to all the Delaware farm families who shared their photographs and memories for this book. Each is acknowledged with their photographs. Those special images reflect the farm family heritage that has made Delaware agriculture so successful for over two centuries.

Thank you to Arcadia Publishing and my editor, Kendra Allen, for the opportunity to write this book and for their guidance. I also thank and appreciate the University of Delaware for providing an environment that allowed this project to take place.

INTRODUCTION

Farming and its related agricultural industries have been a major force in the social, cultural, and economic history of Delaware. Today agriculture remains as the state's largest industry, generating over $1 billion in cash farm income from a wide array of crops, poultry, and livestock, multiplying the economic impact through the economy with associated goods and services. As important as the economic impact is, the agricultural traditions that were formed over 350 years created a lasting agricultural legacy that still permeates the state. Perhaps no greater statement can be made of farming's impact on modern Delaware than the fact that privately owned farmland still accounts for 42 percent of Delaware's land area, or 540,000 acres.

Native Americans in the region were largely hunters and gatherers, but they also made plantings of corn, beans, and squash. Farming was critical to the sustenance and survival for the first European settlers of what would become Delaware. The Dutch arrived at Lewes in 1631. A series of ventures by the Dutch, the Swedes in 1638, and finally the English in 1664 characterized Delaware's settlement and subsequent control of the Delaware Valley. Early settlers produced wheat, barley, Indian corn, peas, and various vegetables in a garden. They raised cattle for meat and milk, pigs, sheep, and goats. By 1663, while the colony was under Dutch control, 110 plantations existed in the Delaware Valley. Collectively, they tended 2,000 cows and oxen, 20 horses, 80 sheep, and several thousand pigs.

With English control of the region beginning in 1664 and the subsequent granting of Pennsylvania to William Penn in 1681, the region stabilized and remained under English rule until the Revolution. By 1704, the three Delaware counties had gained permission from Penn to conduct their legislative assembly separately from Pennsylvania, although they shared the same governor. This was the genesis of a separate Delaware colony, often identified as Pennsylvania's "lower counties," that would become an independent state.

With political stability, trade and economic growth prospered. Philadelphia's emergence as the major trade center created opportunities for Delaware farmers. Grain and other farm products were sent up the river to Penn's "faire country town." New Castle, 30 miles downriver, was often the first stop for incoming ships for freshwater supplies. It was also the last stop before departure for similar last-minute purchases and boarders. Penn authorized a market for New Castle in 1682.

It was tobacco, grown in the two counties below New Castle or rolled overland from Maryland that was the most profitable crop and the main export to England in the early 1700s. Like the Chesapeake colonies, debts and other obligations were paid with tobacco. However, tobacco depleted the soil, which, coupled with lower prices, turned Delaware farmers away from the crop. By 1770, Delaware farmers had abandoned tobacco, and grain became the cash crop for Delaware farmers.

The grain crops—wheat, corn, barley, oats, and rye—gained value as Philadelphia grew and as an export trade developed with the West Indies, Nova Scotia, and East Coast ports. The decline of tobacco, the emergence of grain, and the availability of land in Delaware encouraged an eastward migration of planters from the Eastern Shore of Maryland to Delaware. This is the

origin of many noteworthy Delaware families, with surnames familiar to today's Delawareans, such as the Chews, Mifflins, Rogerses, Mitchells, and Dickinsons. John Dickinson would be a signer of the Declaration of Independence and a member of the Constitutional Convention.

As our new republic was taking root, corn, wheat, timothy and clover hay, barley, oats, rye, and vegetables were Delaware's major crops. Pests like the Hessian fly, scab, rust, and smut along with weeds like cheat, garlic, and cocklebur remain problematic today. Beef cattle were grazed on marshes and in woods, taking four years to reach the age for slaughter, as opposed to 10 months today. Delaware's agriculture was in a period of decline because of exhausted soils and a general lack of progress until the 1830s, when prominent farmers promoted the use of lime, guano, and other progressive techniques. Agricultural societies in each county arose to help advance the knowledge of farming.

It was wheat, specifically soft red winter wheat, that became the new state's first important crop. Dr. James Tilton, an observer of Delaware agriculture during this period, wrote, "It is the prevailing opinion in Delaware, that we have the largest and most perfect manufacture of flour known in the world." This is largely attributed to the mechanical genius of Oliver Evans, of Newport, whose design of flour mills brought great attention to himself and to the Delaware grain and flour industry.

In the 1750s, several Quaker families—the Canbys, the Tatnalls, the Shipleys, the Leas, the Mortons, and the Pooles—founded and sustained a grain milling industry on the Brandywine River at Wilmington that would last for over 200 years. Farmers from Delaware and surrounding counties in neighboring states supplied the wheat for the millers by shipping it up the Delaware from farm landings on the state's tidal rivers and streams or hauled overland by Conestoga wagon from the inland farms. Brandywine mills eventually procured grain from as far away as Virginia and New York to satisfy the demand. Delaware agriculture became a major industry, bringing fame and prosperity to the colony and the new state.

Delaware farmers began to diversify. As always, the potential of a lucrative or at least profitable market drove them to experiment and develop new enterprises. Access to the market was as important as the opportunity. Steamboats were commonplace on the Delaware River after 1815, and the Chesapeake and Delaware Canal was completed in 1829. The canal provided another early agricultural linkage to Philadelphia, whose merchants and businessmen sponsored it to remain competitive with the swiftly growing city of Baltimore.

In 1832, Isaac Reeves planted the first orchard of "budded" fruit trees in Delaware. Budded refers to the vegetative propagation, or grafting, of a variety of peaches to the rootstock, ensuring a whole planting produces the same variety of peach. Maj. Phillip Reybold from Delaware City became the peach king by the 1840s, shipping peaches by sail and steamboat. His success was widely imitated. By 1890, over four million peach trees covered the state. In 1896, Delaware's General Assembly made the peach blossom the official state flower.

The expansion of the peach industry was a direct result of the development and completion of the Delaware Railroad down the length of the state, reaching Delmar in 1859. Orchards were planted down the state as the railroad made its way south. The preservation of foods by canning appeared as an industry in Baltimore during the 1830s and 1840s before spreading to the countryside. The Richardson and Robbins Company in Dover was the first cannery on the Delmarva Peninsula, opening in 1855. By 1889, Delaware had 49 canneries spread across all three counties. Tomatoes, peaches, lima beans, peas, sweet corn, and other products were harvested from Delaware fields, canned locally, and shipped on the railroad across the United States. The industry, now based largely on frozen vegetables, continues today.

At the beginning of the 20th century, 9,687 farms operated in Delaware on 1,066,228 acres. Eighty-four percent of Delaware's land area was in farms. While fruit and vegetables were the signature crops during the 19th century, corn and wheat were always the staple crops. Wheat acreage varied little over the 50-year period from 1880 to 1930. Most of the wheat crop was sold for cash, providing significant farm income over the years. Farmers planted field corn, also a staple, on approximately the same acreage each year from 1890 to 1940. Yields of both crops remained

nearly the same over these periods, averaging 15 and 25 bushels per acre, respectively. During those decades, farmers produced between four and five million bushels annually but consumed three million bushels on their farms each year as feed for livestock and poultry.

Peaches began to decline as a result of a mysterious disease known as "peach yellows." From over 4 million trees in 1890, plantings declined to 2.4 million in 1900, to 1.1 million in 1910, and by 1940 to only 314,684. Fruit growers shifted to strawberries and apples, shipping large quantities by train every season. In 1899, Delaware produced over 10 million quarts of strawberries, with Sussex County producing over 7 million of the crop, making it the largest strawberry-producing county in the nation. This dominance continued into the 1920s. Bridgeville was the center of the industry, shipping over 1.5 million quarts annually, although Selbyville at the southern end of eastern Sussex County harvested the crop slightly earlier and rivaled Bridgeville.

Apples also replaced peaches. The Census of 1900 reported 567,618 apples trees planted in Delaware. The industry grew to 824,348 trees by 1925. The Delaware apple "deal" was based on shipping summer cooking apples in June, July, and August to consumers across the Northeast and into Canada during an era when housewives made their own applesauce, pies, and even canned apples at home. The industry was concentrated in the Camden-Wyoming area, although Bridgeville, Milton, Middletown, and Lewes housed prominent orchards.

Dairying was a widespread enterprise during the first half of the 20th century, especially in New Castle and Kent Counties. Many farms throughout the state milked 15 to 20 cows, but others began to milk more cows to gain efficiency. The most renowned herd of the Holstein-Friesian breed of dairy cows was owned by Henry Francis duPont at his estate, Winterthur. DuPont's breeding program improved the breed dramatically, with Winterthur bulls and cows shipped around the country and the world to dairy producers eager to improve their production.

The most dramatic agricultural development in Delaware's history began in 1923 when Cecile Steele of Ocean View started a brood of 500 chicks and sold them 18 weeks later when they weighed two and a half pounds for 62¢ per pound. She started 1,000 chicks in 1924 and sold them for 57¢ per pound. A commercial "broiler" business was born. The term broilers designated young chickens sold for meat when they weighed two and half pounds. It was typically a summer enterprise, but Steele demonstrated that raising the chickens in the late winter and early spring captured higher prices. Soon her neighbors imitated her success; by 1928, over two million broilers were produced in Delaware, and expansion continued at a pace of over one million birds per year until 1935, when Delaware farmers expanded even more rapidly. By 1944, more than 60 million birds were sold at a price of over $1 per bird.

During the industry's earliest years, the birds were hauled live to New York and Philadelphia markets. The demand primarily existed among the Jewish populations of those cities. In 1938, Jack Udell, a Russian Jew from New York, started the Eagle Poultry Company in Frankford to slaughter, eviscerate, and ship fresh-killed birds to those markets on refrigerated trucks. The construction of the DuPont Highway, or Route 13, was a major factor supporting the marketing and distribution of the processed chickens. Other entrepreneurs followed, and soon poultry plants popped up in towns across Sussex County. During this era, hatcheries produced the chicks, local dealers sold the feed, and the farmers sold their chickens to any one of several companies. During the 1940s, 12,000 railcars of manufactured feed came to Delaware annually from national companies like Swift, Purina, and others.

By the late 1960s, consolidation and vertical integration drove out inefficiencies in the old system. Today four poultry integrators supply the feed and the chicks and process the grown birds. The farmer provides the chicken house, the utilities, and the labor, contracting with a poultry company at a predetermined price. Each week, over two million chickens are slaughtered, processed, and sold from the Delmarva Peninsula.

The demand for food and for poultry during World War II drove prices to all-time highs, generating tremendous income for poultry producers, poultry processors, canners, and farmers in general. The war also signaled the beginning of a whole new system of agricultural technologies that impacted crop production, poultry production, and dairy and livestock production. Pesticides,

manufactured fertilizers, mechanization, irrigation, and genetically improved varieties all combined to break yield barriers. With increased production, demand could not always keep up with supply, creating periodic cost-price squeezes in all segments of agriculture at various times.

Farmers became more efficient, often operating on larger and larger acreages as they purchased or rented the farmland of their neighbors who left farming. The introduction of these technologies was led in large part by the agricultural scientists and extension workers of the University of Delaware. Cooperative extension, by bringing science and knowledge to the countryside, helped moved the farm community from superstition and failing traditions to a modern, science-based agriculture that helps feed the world. In Delaware, the tradition continues over six generations of research and extension workers, who often partner with farmers and agricultural industries to bring the best of the new technologies to the farm.

Today Delaware farming continues to be successful, despite a new set of challenges. Maintaining a competitive edge is a major challenge in the face of production challenges inherent with crop, poultry, and livestock production. Regional and global competition confronts Delaware producers daily. Meeting environmental regulations adds to the cost of doing business. Delaware is losing its farmland to housing and commercial development at an average rate of two percent per year. Farmers and agricultural business persons begin to wonder if there will be enough critical mass of producers, suppliers, and markets to support Delaware's agricultural economy.

Yet there are positives. Grain prices are strong because of the national demand for ethanol and other bio-fuels. Increased land values have moved farmer's equity to all-time highs. Farmers have invested over the past 30 years in developing irrigation, and much of Delaware lies over bountiful and productive aquifers. The demand for chicken both domestically and internationally, although subject to periodic price drops, is still expanding.

There can be no doubt, however, that the biggest asset in Delaware farming lies with the farmers and farm families whose hard work, skill, and strength seem to thrive and prevail over the 350 years.

One

Fundamental Factors of Delaware Agriculture

Delaware's location is critical to its agricultural development. The state is centered on the eastern coast of the continent, with a bay and river that beckoned the first settlers. Its climate, terrain, and soils were supportive of settlement and farming from the first. Today its location places it within one day's marketing distance of one-third of the nation's population.

The average temperature in July is 76 degrees Fahrenheit. The average annual precipitation is 45 inches, leaching the soil's soluble materials and creating acidic soils. The frost-free growing season averages 180 days, essentially from May through October.

Ninety-four percent of Delaware's soils lie in the coastal plain, delineated by the region south of a line drawn roughly between Wilmington and Newark. The coastal plain is a flat to gently undulating plain with elevations ranging from 40 to 125 feet above sea level. The plain generally slopes gently upward and westward from the Delaware Bay to the Chesapeake Bay watershed and gently downward from there westward. At the lower elevations, soils tend to be poorly drained because of the lack of fall. With artificial drainage, these naturally poorly drained soils become productive. The coastal plain soils are sandy, highly leached and acidic. They are very permeable, with little capacity to hold water. The other soil region is the piedmont region, the rolling foothills of the Appalachian Mountains. These piedmont soils contain more silt, hold moisture well, and are naturally more fertile.

Droughty summer conditions and the sandy soils of the coastal plain soils conspire to reduce crop yields. Fortunately much of this region sits above aquifers that provide a tremendous reservoir of fresh water for irrigation use as well as domestic, municipal, and agricultural use. This irrigation resource has been significantly developed since 1970. Today nearly 20 percent of Delaware's cropland is irrigated.

These natural geographic, geologic, and climatic factors have combined to foster the agricultural initiatives of Delawareans for over three centuries. As a result, agriculture maintains a major role in the prosperity, quality of life, and social traditions of Delaware.

This rolling field being cultivated in Northern New Castle County is typical of the piedmont region of Delaware. The hills of the piedmont region are a quite different physiographic zone than the flat coastal plain zone that extends from southern New Castle County to the southern border of the state. This farmer was working his ground on April 21, 1936. (Courtesy Delaware Public Archives.)

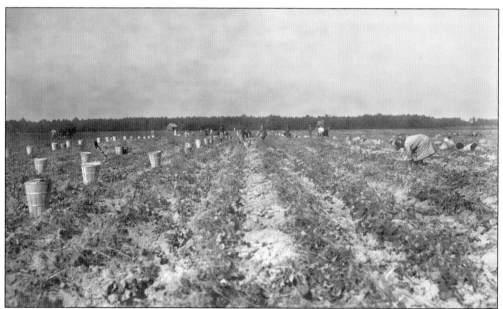

The flat coastal plain topography that makes up the majority of Delaware's farmlands is evident in this sweet potato field being harvested on October 18, 1922, at the Culver Farm, near Laurel. This type of landscape is typical of the part of the state south of the Chesapeake and Delaware Canal. (Courtesy Delaware Public Archives.)

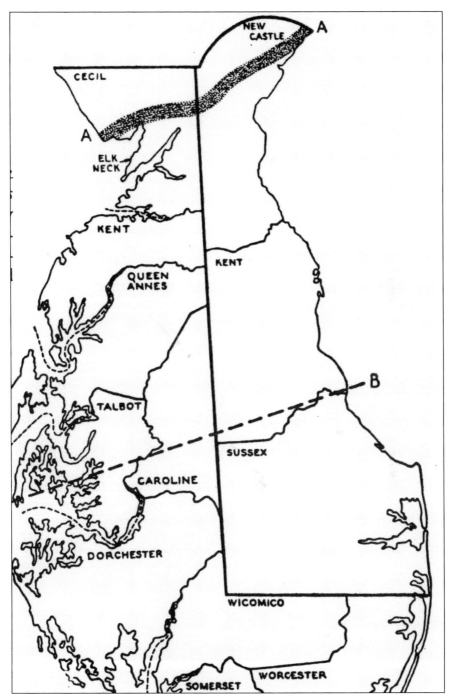

Delaware's position as an independent state resulted from the settlement at Lewes in 1631, which preceded the establishment of the Maryland colony. Famed surveyors Mason and Dixon established the southern, western, and northern boundaries of the colony. The piedmont region lies above the line A-A and consists of heavier silt and loam soils. The remainder of the state is part of the coastal plain, characterized by lighter, sandier soils. Line B-B marks the northern boundary of the loblolly pine, *Pinus taeda*. (Courtesy *Delaware: A History of the First State*.)

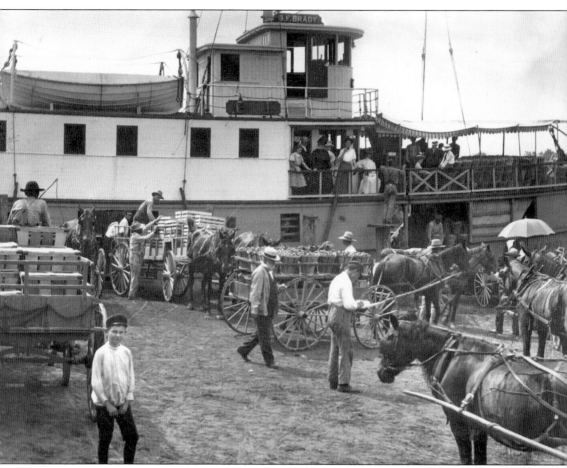

Sailboats and steamboats were critical to farmers as they shipped grain and produce to market. Farmers shipped grain to the mills in Wilmington and Philadelphia from the tidal streams and creeks near their farms. Farmers began to ship peaches and other perishable fruits and vegetables to Philadelphia, Baltimore, New York, and Boston markets in the 1830s. This steamboat is the G. F. Brady, loading peaches and other produce at Smyrna in 1908. (Courtesy Delaware Agricultural Museum and Village.)

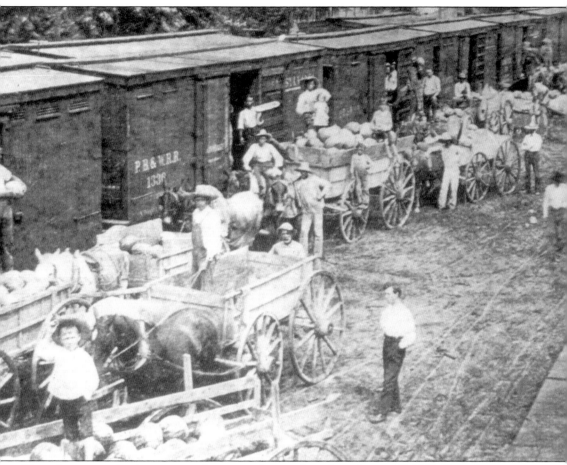

These farmers are loading watermelons on railcars at Laurel on August 17, 1905. Forty-five cars were loaded with 1,200 melons per car. The value of this train load was $30,000. By 1880, the railroad had supplanted water transportation as the major connector from farm to market. The Delaware Railroad was started in 1853 and reached the southern end of the state at the town of Delmar in 1859. As it moved southward from Wilmington, the railroad spurred new plantings of fruits and vegetables for shipment to urban markets. By 1889, Delaware was home to 49 canneries, which utilized the railroad to ship canned goods to markets across the United States. (Courtesy Delaware Public Archives.)

In 1916, T. Coleman DuPont financed the construction of a modern highway that ran the length of the state, from Wilmington to Selbyville. This photograph of the highway between Georgetown and Milford was taken on September 24, 1923. The DuPont Highway changed Delaware's agriculture, linking its farms to city markets with greater speed and flexibility than the railroad or water transportation. It would enable the poultry industry to flourish and become a phenomenon that continues today. (Courtesy Delaware Public Archives.)

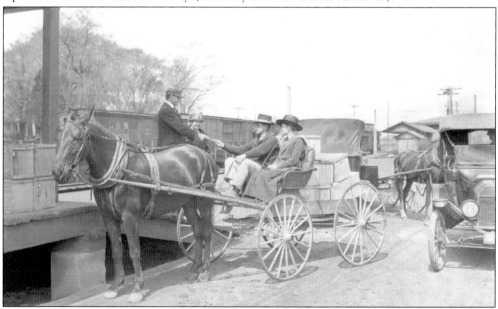

The horse, the train, and the automobile are evident at the railroad station in Milford as this farm couple delivers their farm products for shipment on the train in the 1920s. The crates are strawberry crates, with quart boxes sequestered inside the crate. The income from these transactions provided important cash to farm families as they worked towards an improved quality of life. (Courtesy University of Delaware Cooperative Extension.)

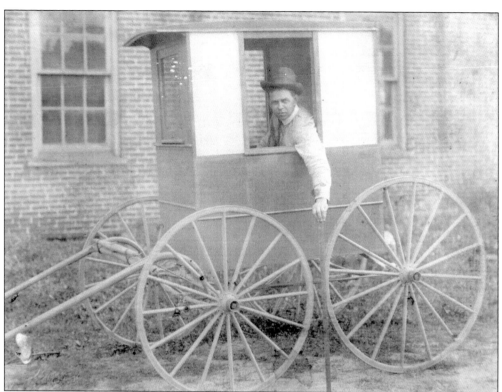

Rural Free Delivery of mail helped improved communication with the world away from the farm, improving the quality of life for rural families. This one-horse wagon for rural mail delivery c. 1900 with the driver, Will Bradshaw, demonstrating the easy reach for rural mailboxes was a welcome sight for farm families. (Courtesy Delaware Agricultural Museum and Village.)

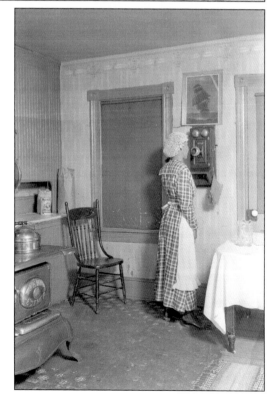

The telephone brought an instant connection from the farm to town. This homemaker in her kitchen enjoys a new woodstove and telephone in her home on a Sussex County farm in the 1920s. During the 1920s, the telephone system began to spread out to the countryside, although many farms did not enjoy telephone service until the 1940s. (Courtesy University of Delaware Cooperative Extension.)

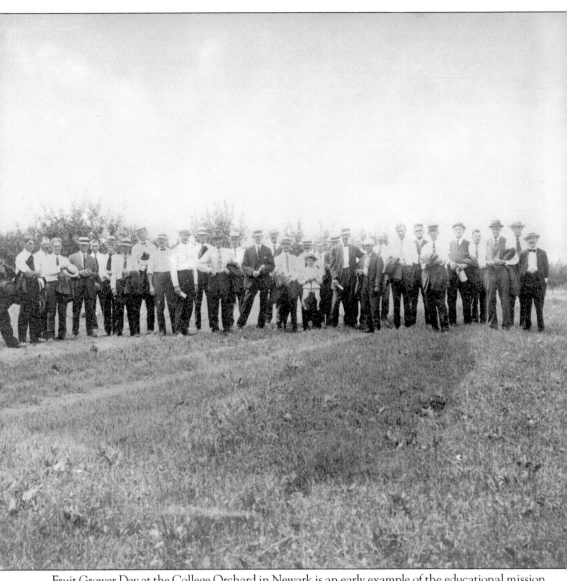

Fruit Grower Day at the College Orchard in Newark is an early example of the educational mission in agriculture of the University of Delaware. The university, like its sister land grant institutions across the country, was established with the Morrill Act of 1862. The creation of a land grant college system became the envy of the world. For the first time, a college education was available for the lower and middle classes. The Hatch Act of 1887 created the Agricultural Experiment Station to conduct research at the land grant college. In 1914, the Smith-Lever Act created the Cooperative Extension Service to bring knowledge out from the campus to the people. (Courtesy University of Delaware.)

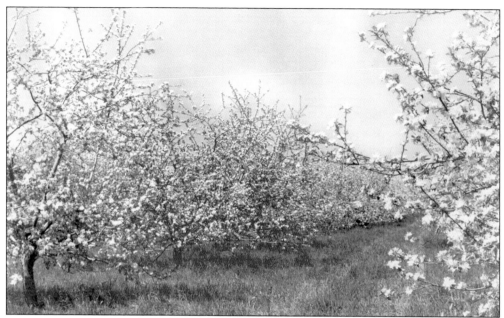

Apple orchards in blossom like the one above, as well as peach orchards, were a prominent part of Delaware's farm scene from the 1830s until the 1950s. The peach boom began in 1832 with the planting of the first budded orchard of peaches by Isaac Reeves near Delaware City. By the early 1900s, a virus-like disease called peach yellows, below, had mysteriously decimated Delaware's orchards. It is now known the disease is spread by aphids and is easily controlled. With the decline of the peach industry, Delaware farmers turned to apples. By the 1930s, Kent County had more apple trees per square mile than any other county in the country. (Courtesy University of Delaware.)

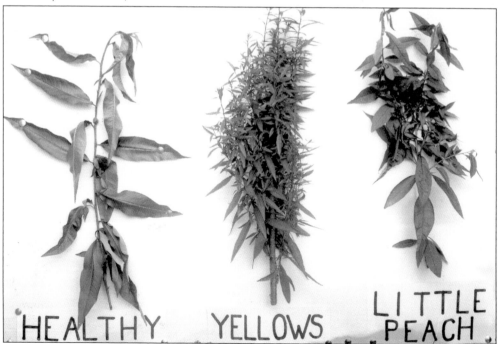

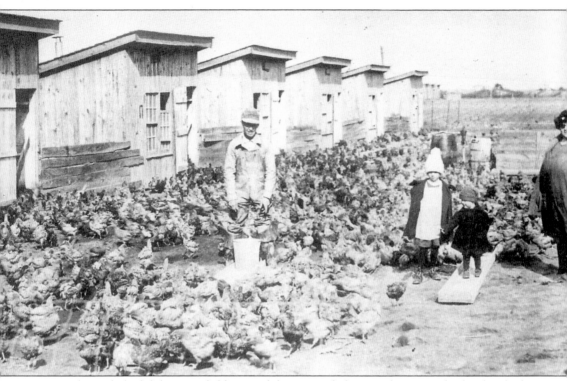

Cecile Steele (right), her two children, and Ike Long, a helper, tend Mrs. Steele's broiler chickens. In 1923, Mrs. Steele inadvertently started Delaware's largest agricultural industry. Each spring, she ordered 50 new chicks to replace losses in her laying flock. That year, the hatchery sent 500 chicks. Rather than correct the hatchery's mistake, Mrs. Steele kept them and sold them 18 weeks later at two and a half pounds apiece for 62¢ per pound to a local buyer who sold them to restaurants and hotels. With her success, raising poultry for meat became a new enterprise that would come to dominate Sussex County's and Delaware's agriculture to this day. (Courtesy Delaware Agricultural Museum and Village.)

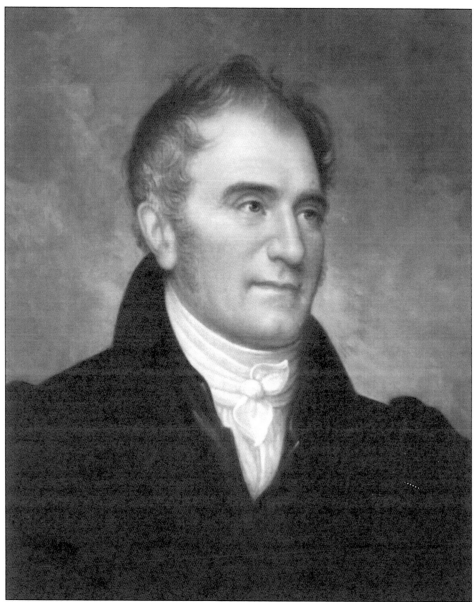

E. I. duPont founded his black gunpowder mills in 1802 on the Brandywine River north of Wilmington. Arguably, duPont could be considered the individual in Delaware history with the greatest influence on the state's agriculture. An immigrant from France, duPont listed his occupation as "Botaniste" on his passport. While developing his company, he also made his home and farmstead, Elutherian Mills, a successful farm enterprise. His son Henry became the largest landowner in the state and took a keen interest in agricultural improvement. E. I.'s great-grandson, Henry Francis duPont, created the Winterthur Gardens, and another great-grandson created Longwood Gardens in neighboring Pennsylvania. Another descendant, T. Coleman duPont, created a modern highway that ran the length of the state, stimulating farm and economic development throughout the state. The modern DuPont Company began developing agricultural chemicals in the 1940s and remains a world leader in agricultural technologies today. (Courtesy University of Delaware.)

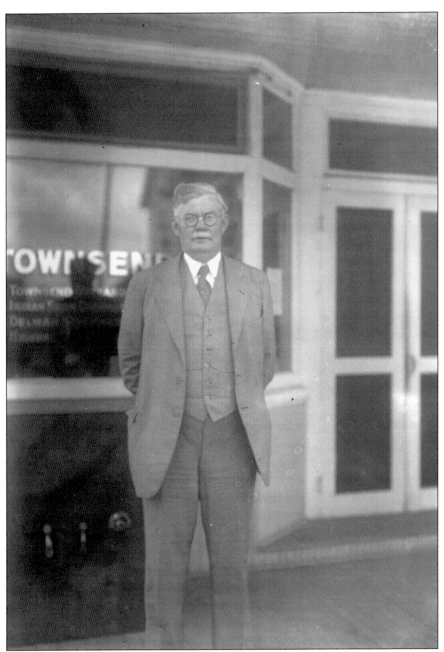

John G. Townsend Jr. was born in 1871 on a farm near Bishopville, Maryland, just a few miles south of Selbyville, Delaware. He had tremendous impact on Delaware's agriculture industry. Arriving in Selbyville as a railroad telegrapher in 1894, he soon became involved in timber, brokering and shipping strawberries, apple production, peach production, and farming of all types. He was instrumental in assisting T. Coleman duPont acquire the land and constructing the Sussex County portion of DuPont Boulevard. Elected governor in 1916 and U.S. senator in 1928, Townsend was well-known throughout Delaware and the nation. In the 1930s, he, along with his son Preston, successfully entered the poultry industry. Townsend Hall, the main agricultural building at the University of Delaware, is named in his honor. (Courtesy Delaware Public Archives.)

Two

NEW CASTLE COUNTY

New Castle County is the northernmost county in Delaware. It is the only county with two distinct physiographic characteristics. The Piedmont Plateau, which lies north of a line drawn between Wilmington and Newark, consists of sloping to hilly terrain. The soils in the piedmont tend to be fertile and very productive. Their slope, however, can lead to erosion. South of the piedmont lies the coastal plain, running all the way to the county's southern boundary. The coastal plain soils are nearly level and can also be very fertile. They tend to be loams or silt loams, heavy enough to hold soil moisture and with a natural fertility. Dairying was the leading enterprise in the 20th century, especially on the piedmont but also on the coastal plain.

Marshes and wetlands lie along its eastern boundary on the Delaware River. The waterfowl, muskrats, and deer that live in that habitat provided an important source of food and income over the centuries. Today that tradition continues in the form of leased hunting rights.

It was in New Castle County that the production of perishable fruits and vegetables first emerged as a market-oriented enterprise. Maj. Phillip Reybold became known as the "Peach King" for his large orchards near Delaware City.

Middletown became the center of agriculture for the county with the development of the railroad in the 1850s. Peach orchards radiated out from the town for several miles, along with fields of tomatoes, sweet corn, and other vegetables for market and canning. The land west of Middletown, known as "the levels" for its flatness, is the best farmland in the state.

Corn has been the most extensive crop over the years and remains so today, although soybeans and wheat are very important. Vegetable and potato production, a major farm activity until recently, has diminished greatly since 1990.

Farming was the dominant activity on the land south of the Chesapeake and Delaware Canal until the early 1990s. Housing and other development has pushed south until, as one farmer sadly puts it, "Today, houses are the best crop we grow."

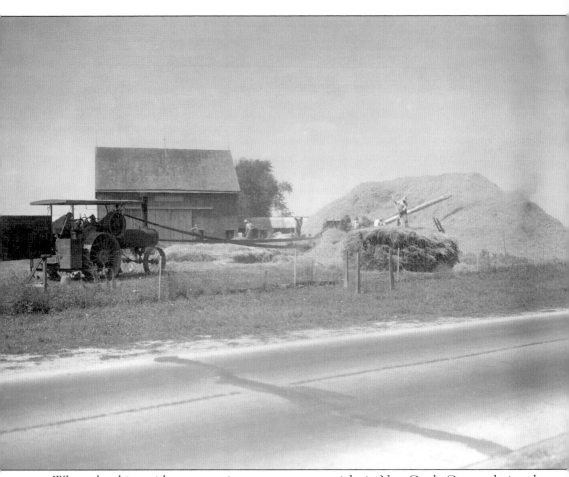

Wheat threshing with steam engines was a common sight in New Castle County during the 1920s and 1930s. This wheat is being threshed near State Road, close to the Route 13 and 40 split, on August 27, 1925. That year, New Castle County farmers grew wheat on 37,048 acres, averaged 18.5 bushels, and received $1.47 per bushel. Wheat was the most widely planted crop in the county. The second most widely planted crop, corn, was planted on 23,968 acres in the county that year. (Courtesy Delaware Public Archives.)

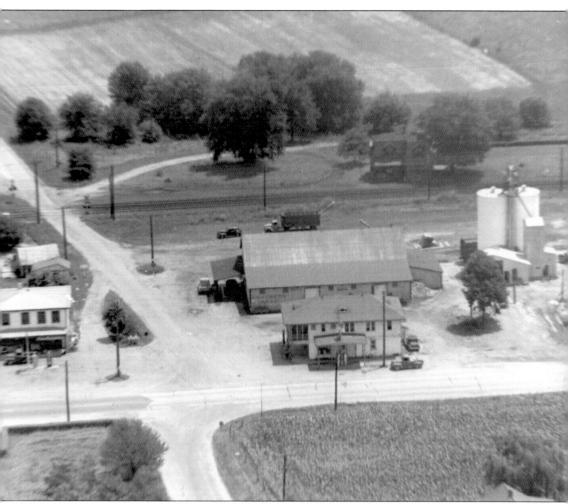

Carothers Brothers Granary, shown here in 1951, was a fixture for southern New Castle County farmers for years at the crossroads known as Mount Pleasant, just a few miles north of Middletown. The Carothers brothers operated the granary behind the white building with the gas pumps, which was their general store and later a hardware store. The road in front of Carothers is Route 896/72. The road that extends from the main road to the top of the photograph goes east to Boyd's Corner and Route 13. The two-story building in the upper right, adjacent to the railroad, was the Mount Pleasant train station. Carothers sold the property to Townsend's, a large poultry processor from Sussex County in 1971. All the buildings in the photograph were demolished in the 1990s to make way for a shopping center and an improved highway. (Courtesy Jim Carothers.)

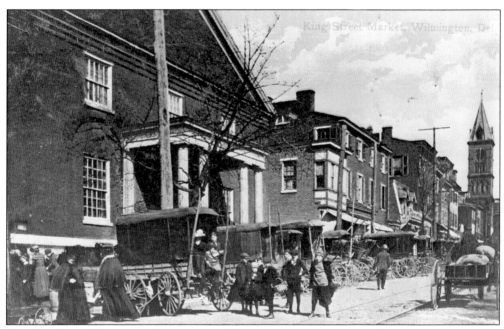

The King Street Market was important for Wilmington consumers as well as being an important market for farmers. All types of fruits, vegetables, eggs, dairy products, and meats were sold. The market established itself in the mid-1800s and continued into the 1960s. Above, farmers with horse-drawn wagons set up for the day c. 1901. Below, a still-active market that uses trucks attracts consumers in the early 1950s. (Courtesy Delaware Agricultural Museum and Village.)

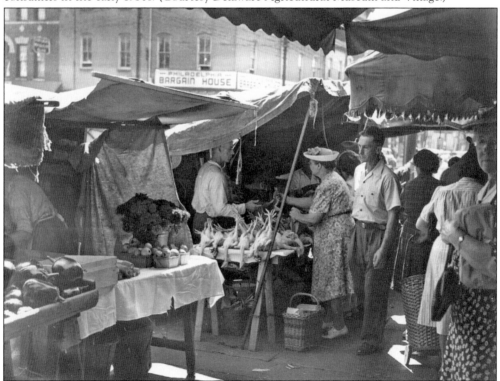

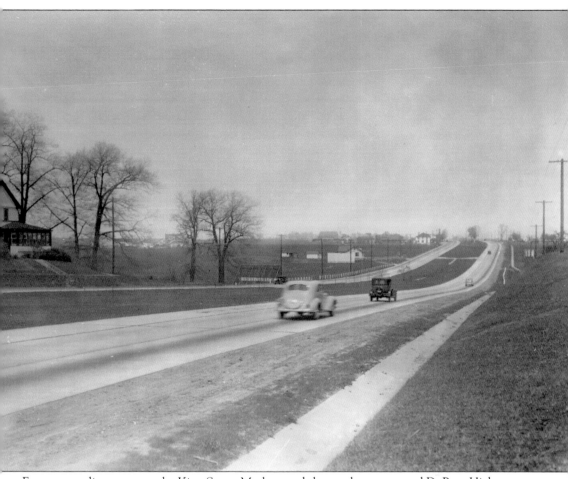

Farmers needing to get to the King Street Market used the newly constructed DuPont Highway, or Route 13, to travel from southern Delaware into Wilmington. The traffic is light on this day, April 21, 1936, near New Castle. Farmers hauling poultry or produce also used the highway to connect to the New York and Philadelphia markets. The DuPont Highway was the main artery for Delaware commerce until the opening of the limited access highway, Route 1, in the 1990s. (Courtesy Delaware Public Archives.)

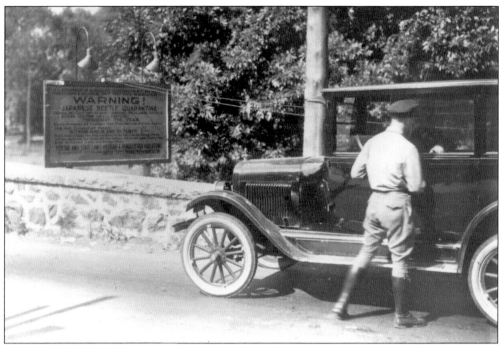

Fruit production was a critically important industry from the 1800s into the 1960s. The Japanese beetle threatened the yields and quality of peaches, apples, grapes, and other crops. With limited choices in pesticides during the 1920s, and increasing motor vehicle transportation that could carry the pest, Delaware established a Japanese beetle inspection system to try to limit the introduction and movement of the pest. College students and others found extra summer income as inspectors. Both photographs were taken in 1925 near State Road. Peaches are being inspected in the lower photograph. (Courtesy Delaware Public Archives.)

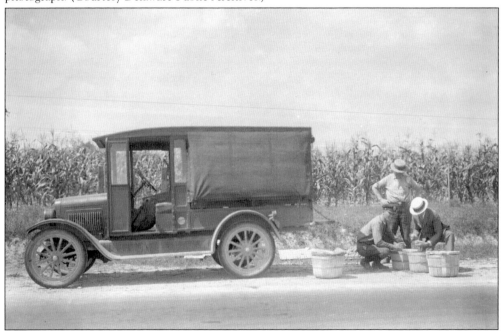

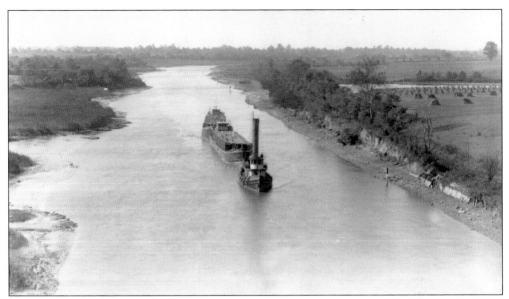

This tug pulling barges through the Chesapeake and Delaware Canal is approaching St. Georges on November 11, 1931. Note the corn shocks in the field on the right. The canal, opened in 1829, connects the Chesapeake Bay and the Delaware River. It has served as a dividing line between northern and southern Delaware ever since. The land south of the canal in southern New Castle County, Kent County, and Sussex County has been largely agricultural, while much of the area north of the canal has been urban and industrial. (Courtesy Delaware Public Archives.)

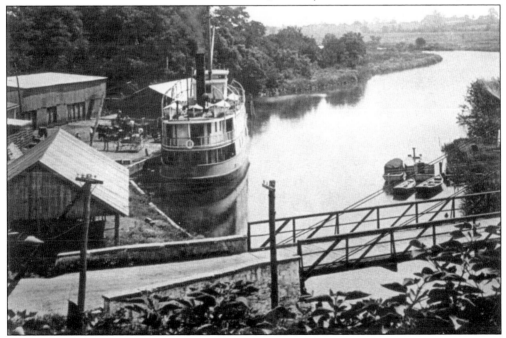

The steamer *Clio* docked at the Odessa landing in 1899. Odessa served as an important point of transportation for farmers from southern New Castle County to Wilmington and Philadelphia. Fruit, vegetables, and other farm products were shipped from Odessa. (Courtesy Delaware Agricultural Museum and Village.)

The residence and farm of H. G. Passmore, shown at left in 1898, was on the Concord Pike where the Concord Mall now sits. The Passmore family, a large Quaker family, farmed in the area along the Concord Pike, now a heavily developed commercial and residential area. The windmill picture below was on the farm of Edward B. Passmore in 1899 on the Kennett Pike, a few miles west of the Concord Pike. (Courtesy Delaware Agricultural Museum and Village.)

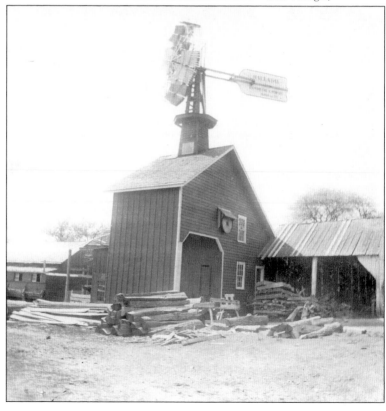

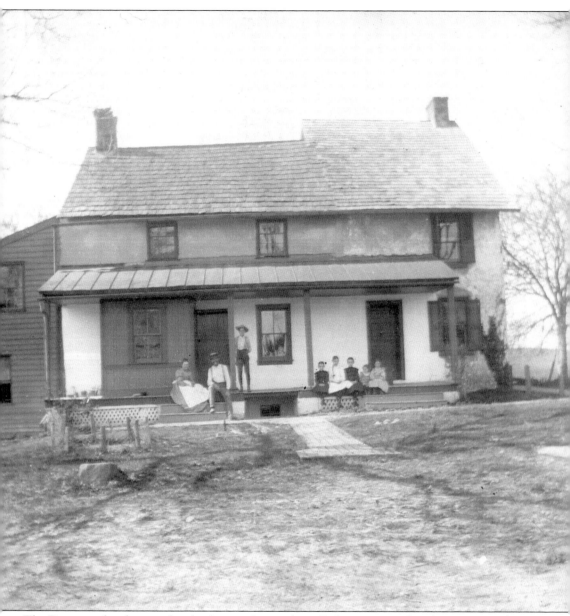

The Passmore family served as leaders in the northern Delaware agricultural community for decades. This family portrait on the porch of the Edward B. Passmore family includes, from left to right, Mrs. Samuel Passmore, Samuel Passmore, Edward B. Passmore, and Mary, Helen, Hannah, Lydia, and Sarah Passmore. (Courtesy Delaware Agricultural Museum and Village.)

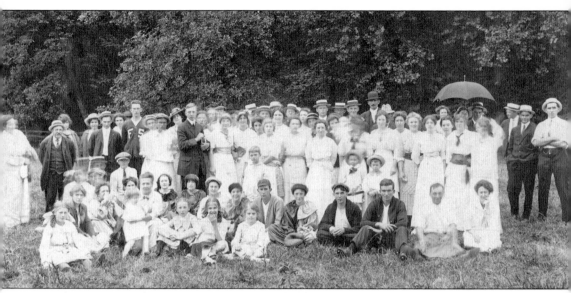

This West Brandywine Grange picnic was held in Harry Ramsey's meadow sometime in the early 1920s. Pusey Passmore is standing under the umbrella; Dora Passmore is to the left of him. Mary Passmore is third from the right in the row of girls. Ed Ryan is second from the right with his arms folded; to the left of him is Willard Galbreath. The Delaware State Grange is the oldest continuing farm organization in the state. The West Brandywine Grange was part of the state Grange system. (Courtesy Delaware Agricultural Museum and Village.)

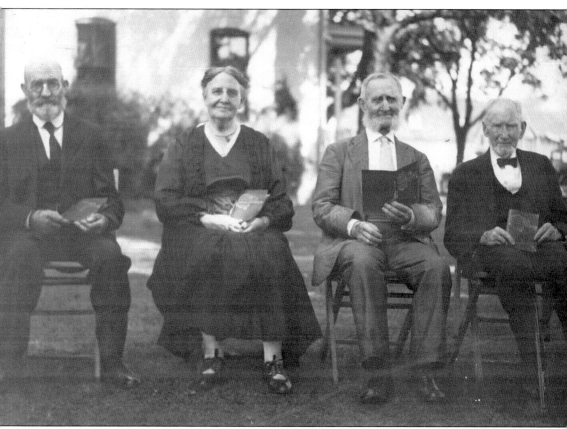

These four members of the West Brandywine Grange received their 50-year member certificates in 1924. The 50-year members were, from left to right, John Heyburn Talley, Letitia Talley, Elihu Talley, and George Weldin Sr. Several families farmed in the area for generations: the Passmores, the Talleys, the Weldins, the Ramseys, and the Woodwards. (Courtesy Delaware Agricultural Museum and Village.)

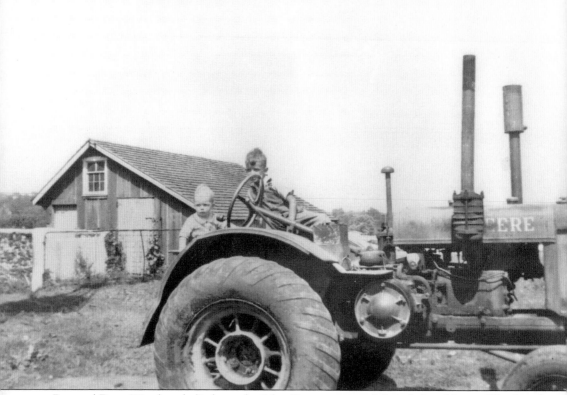

Ray and Dave Woodward climb on the John Deere tractor of their father, Horace Woodward, in 1939. This tractor is purported to be the first rubber-tired tractor in Delaware. When Horace purchased the tractor at his farm, his neighbors and relatives who farmed along Limestone Road near Hockessin, Delaware, scoffed at the tractor, saying, "It wouldn't pull the hat off your head." In 1958, Horace sold that farm and purchased a farm in Middletown. Ray went on to manage the Mount Pleasant grain facility for Townsend's, Inc., and Dave became a legendary county agent in Kent County, Delaware. (Courtesy David H. Woodward.)

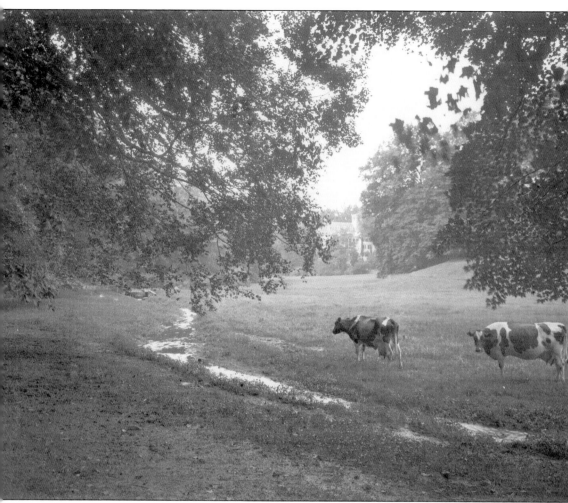

The Holstein-Friesian cows grazing on this pasture were part of the Winterthur Farms herd. The Winterthur mansion of Henry Francis duPont can be seen through the clearing. H. F. duPont, the grandson of E. I. duPont, would create three institutions at Winterthur. The museum would be the world's premier museum of American decorative arts. The gardens are one of the finest examples of naturalistic plantings. However, duPont's primary commitment was to develop a perfect breed of Holstein-Friesian dairy cows. He accomplished his mission; Winterthur Farms was the premier dairy herd in the world from 1919 to 1969. (Courtesy the Winterthur Library: Winterthur Archives.)

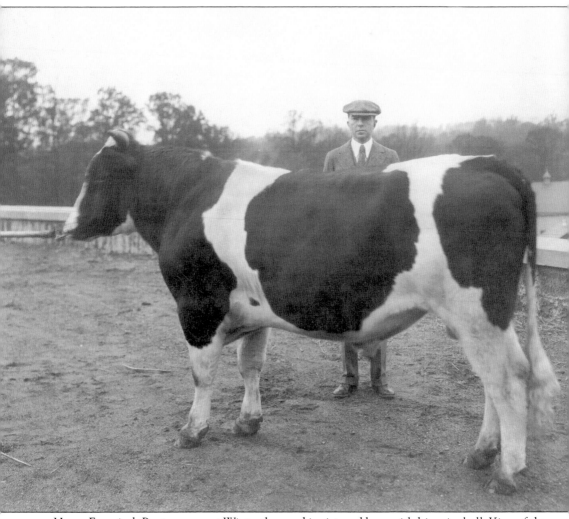

Henry Francis duPont grew up at Winterthur and is pictured here with his prize bull, King of the Ormsbys. Writing in 1962, he stated, "I was born at Winterthur and have always loved everything connected with it. I knew how to milk cows—I knew about everything. When you live on a farm, you know everything that is going on." In 1914, when he was 34 years old, duPont told his father of his intent to sell the mixed herd of Guernsey and Holstein cattle and develop a better, more productive breed. Approvingly, his father stated, "It won't cost as much as a yacht and it might do more for humanity." By 1918, H. F. had completed the purchase of a prize herd from Minnesota and began a systematic breeding program. As a result, Winterthur cows would hold milk production records for decades. The genetic base of the Winterthur herd would be disseminated to farms around the country and around the world, making good on the hope of his father to do good for humanity. (Courtesy the Winterthur Library: Winterthur Archives.)

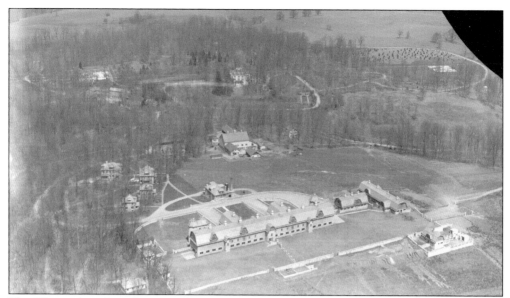

The Winterthur dairy barns and complex were among the most advanced in the country. Construction began in 1917 and included reinforced concrete floors, a sophisticated ventilation system, and huge silage and hay storage capacity. In total, over 300 Holsteins were producing 11,000 pounds of milk per cow annually. The milk was processed on site, with Winterthur milk, butter, and cream highly appreciated by consumers in nearby Wilmington. The complex included the main barn, a test barn, several calf barns, a hospital barn, and the creamery. Above, duPont's mansion is in the top center and is smaller than the existing mansion, which can be seen in the photograph below of the main dairy barn after the devastating fire of August 1930. Fortunately, no cattle or human life was lost. The expanded mansion is seen in the top center. (Courtesy the Winterthur Library: Winterthur Archives.)

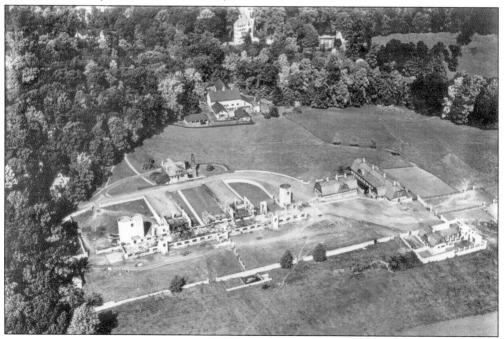

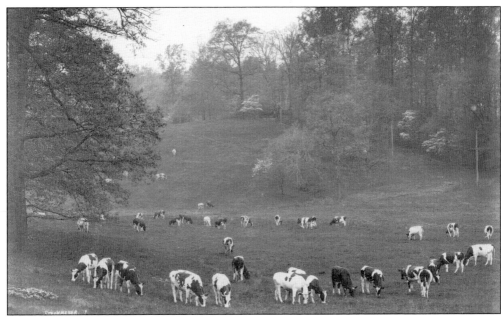

The Winterthur herd enjoyed lush, productive pastures. The soil characteristics provided a perfect setting for grass growth. The productivity of the pastures, coupled with the improved genetic basis of the herd, high-quality silage, and the ventilated, sanitary conditions in the barn, created an ideal environment for cows and milk production. The farm also produced beef, sheep, poultry, vegetables, and fruit for duPont's table. He insisted that as much of his food as possible be produced at Winterthur. Below, the Shropshire sheep herd winters in one of the many Winterthur barns that dotted the estate away from the dairy complex. (Courtesy the Winterthur Library: Winterthur Archives.)

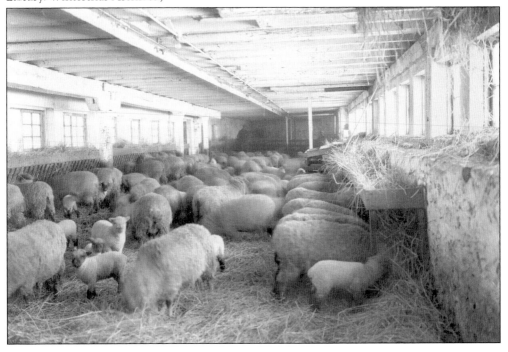

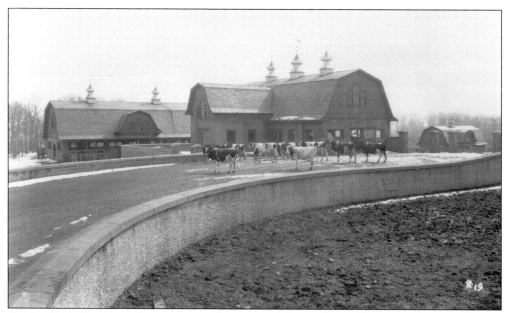

Originally duPont had the test cows, those cows selected for milk production competition, milked four times daily in the special test barn shown above. The cows were kept and fed here under ideal conditions. After several years, duPont decided to milk only two times per day, just like a conventional farmer, and use that production data for competition. Despite fears of his colleagues that the Winterthur herd would lose its competitive position, the herd continued to produce at the highest levels, further proving the value and productivity of the herd. Several cows exceeded 20,000 pounds of milk per year at a time when the state average was just over 4,000 pounds per cow per year. The expanse of the main barn, over 600 feet long, is seen below. Ninety-six cows could be placed in stanchions and milked at once. (Courtesy the Winterthur Library: Winterthur Archives.)

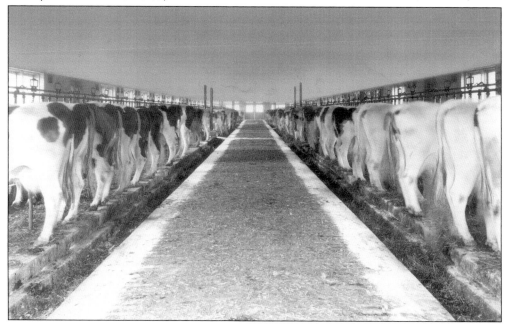

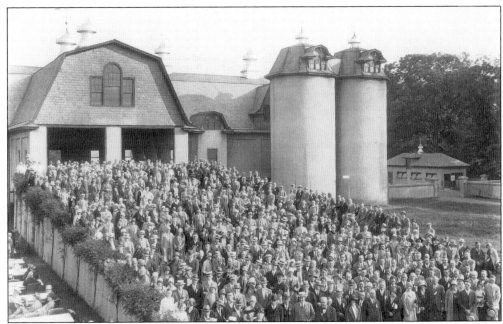

In 1928, the National Holstein Association held their annual convention in Philadelphia and visited Wilmington. The group is pictured above on one of the entryways into the main barn. They left Philadelphia in the morning, traveled to Wilmington on a steamship where they were met by buses to make the 8-mile trip out to Winterthur Farms. DuPont hosted the group with a tour of the farm and lunch (note the tables to the left). The group then traveled to P. S. duPont's Longwood Gardens for dinner, an organ recital, and a fountain show before traveling back to Philadelphia that evening. Below, H. F. duPont proudly shows the leaders of the association one of his prize cows. The association returned to Winterthur in 1955. (Courtesy the Winterthur Library: Winterthur Archives.)

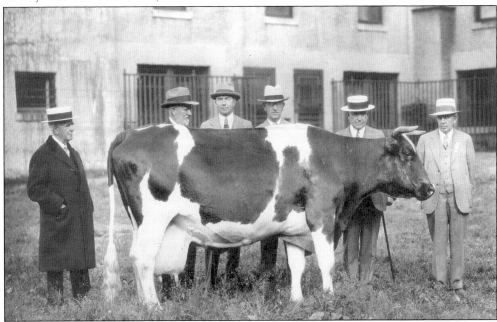

Just a few miles away from H. F. duPont and Winterthur Farms, people from the lower end of the socioeconomic scale were establishing themselves and a new industry. Mushroom production was emerging as a farm enterprise in northern Delaware, near Hockessin, and to a much larger degree across the state line in Kennett Square, Pennsylvania. Many mushroom producers were Italian immigrants or first-generation Italian Americans, like Corrado Amabili, shown here in the 1930s. In Delaware, the industry would grow to produce as many as eight million pounds per year and generate over $5 million of income in the 1980s. (Courtesy the Delaware Agricultural Museum and Village.)

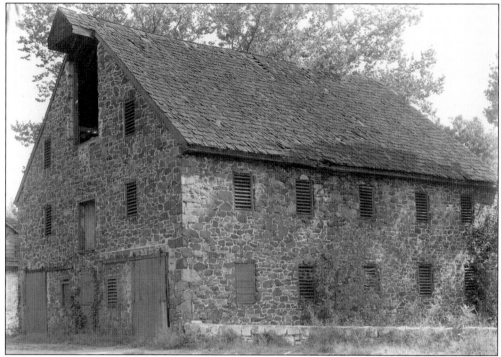

Barns were an important part of the rural landscape throughout New Castle County. Farmers used the most readily obtainable building materials for their barns. Above, Kirk's Barn, made of stone, is in Rockland near the Brandywine River. Below, the Buttonwood Barn, near the Delaware River just north of the town of New Castle, used brick and wood. (Courtesy University of Delaware Special Collections: Willard Stewart Collection.)

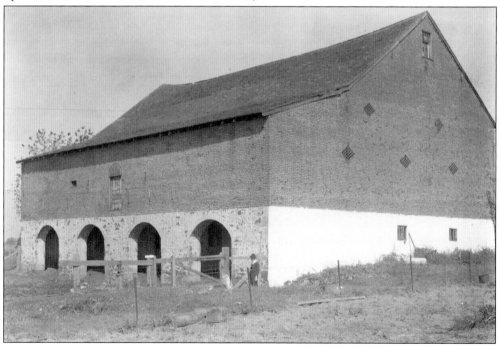

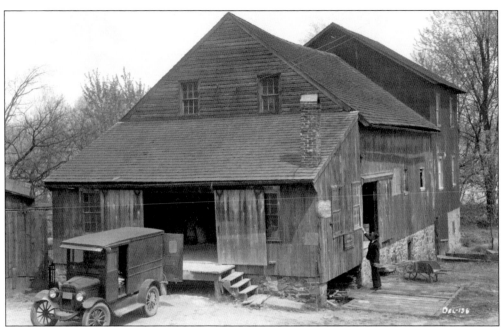

Gristmills operated throughout the county well, turning grain into flour for farmers and other customers. The John English Grist Mill, shown here in the 1930s, operated near Ogletown. Oliver Evans, a Delaware native, designed and implemented many of the principles for grain milling and flour manufacture in the late 1700s with the mills along the Brandywine River. (Courtesy University of Delaware Special Collections: Willard Stewart Collection.)

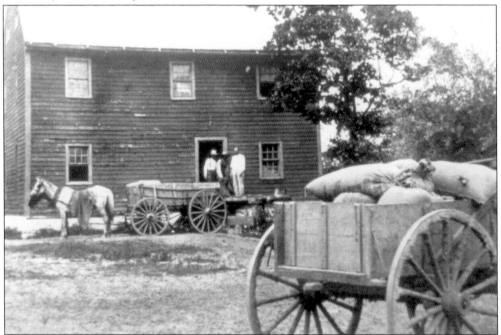

The men are loading flour on a wagon at the Noxontown Mill near Middletown in 1904. Note the hole in a bag on the wagon at the right that is plugged with a corn cob. (Courtesy Delaware Agricultural Museum and Village.)

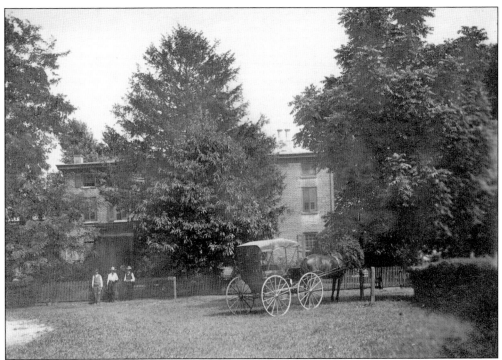

The home on the Shallcross Farm north of Middletown was built in 1853. Below, one of the Shallcross fields was planted in potatoes in 1913. New Castle County farmers produced potatoes on nearly 2,500 acres during this era. World War I stimulated potato production throughout the state. (Courtesy Delaware Agricultural Museum and Village.)

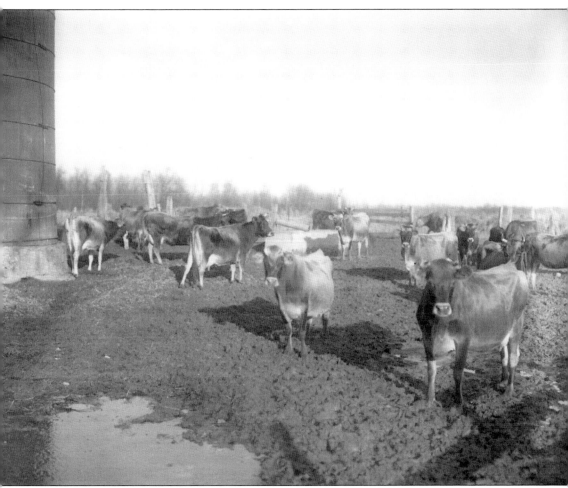

This 1932 scene of the Jersey dairy herd of William Price near Middletown is typical of the era. In New Castle County, over 12,000 cows were being milked annually. More than 40,000 cows were being milked annually throughout the state. The state average for milk production per cow was 4,200 pounds per year. Delaware farmers in 1932 received $1.60 per 100 pounds of milk, a price that reflected the economic depression of the 1930s. Just two years earlier, the price was $2.90. Today it approaches 17,000 pounds per cow per year, with several herds exceeding 20,000 pounds. Today's price ranges from $11 to $14 per 100 depending on supply and demand. (Courtesy Delaware Public Archives.)

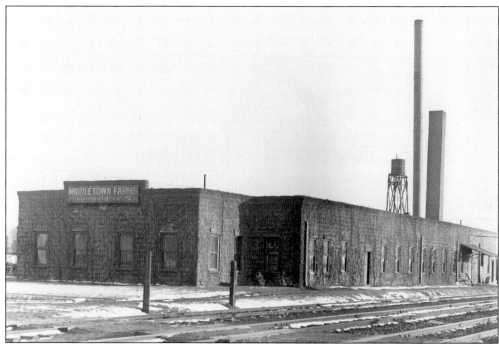

Middletown Farms was a milk-processing plant located between the railroad tracks and the back of the old Middletown High School. The firm purchased milk from area farmers, who either delivered the milk in cans themselves or had it picked up by the company. Not all farms had cows, but those that did milked an average of 32 cows, twice daily. (Courtesy Delaware Agricultural Museum and Village.)

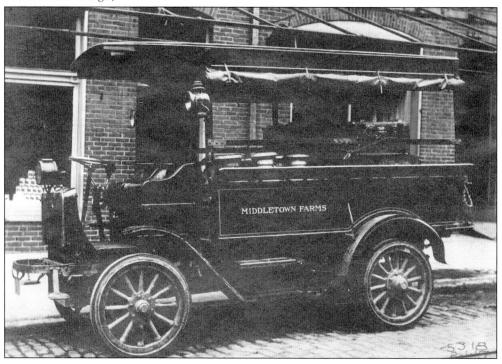

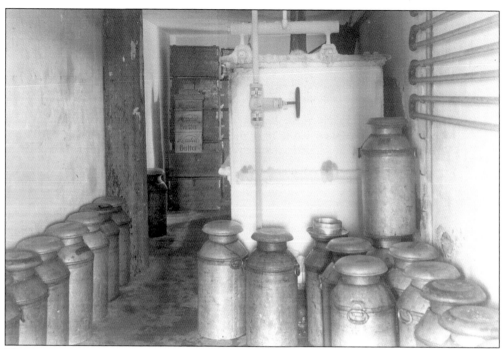

The interior operation of Middletown Farms was modern and utilized the most up-to-date equipment. Although the microbiology of bacteria such as tuberculosis and infecting people though milk had been established by Louis Pasteur in the 1860s, commercial pasteurization plants did not become widespread until the 20th century. Cities and states began to pass regulations requiring milk to be pasteurized before it can be sold. (Courtesy Delaware Agricultural Museum and Village.)

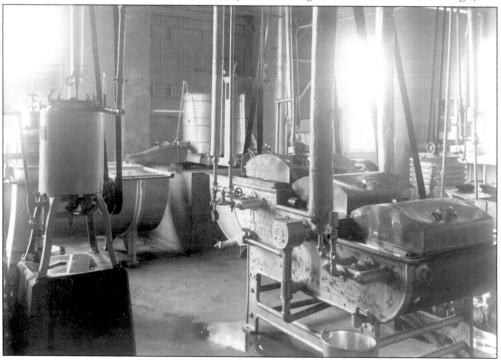

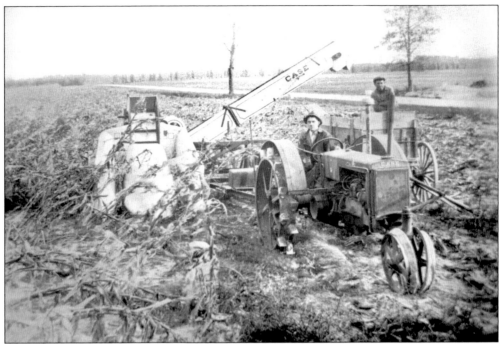

Mechanized farming began to make real strides in the 1930s and 1940s. The steel-wheeled tractor and one-row corn picker shown here in southern New Castle County are struggling on wet ground. The loam and silt loam soils in that part of the county are the best in the state for corn production. (Courtesy Delaware Agricultural Museum and Village.)

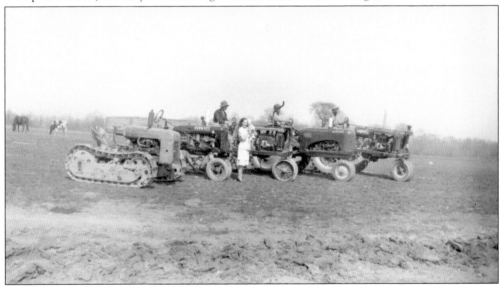

The fleet of tractors owned by Corbit Collins and shown in this 1953 photograph illustrates the progress and importance of tractors to farming. All of the tractors are manufactured by International Harvester; from left to right are a 1940 H tractor, a 1939 M tractor, a 1948 M tractor, and a 1953 M tractor. From a peak of 34,000 horses and 9,000 mules in 1916, only 5,000 horses and 1,000 mules still worked on Delaware farms by 1953. (Courtesy Delaware Agricultural Museum and Village.)

The Middletown area soils were not only productive for corn but also extremely productive for vegetable crops. Tomatoes, especially, became an important cannery crop. The University of Delaware Cooperative Extension Service sponsored the Ten Ton Tomato Club, a neighborly contest designed to share the best production techniques with farmers. Above, extension horticulturist Bob Stevens drives the car while county agent Ed Schabinger measures the acre. Below, Stevens presents the 1953 county award to Fred Haas, who farmed near Route 13 south of the Chesapeake and Delaware Canal. Gov. Cale Boggs (third from left) and an unidentified man look on. (Courtesy Delaware Agricultural Museum and Village.)

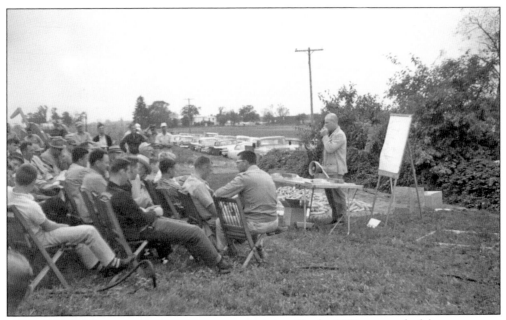

By the 1950s, a wonderful team of University of Delaware Cooperative Extension Agents and Specialists developed field trials and demonstrations throughout the state to show farmers the latest technologies. Above, Middletown-area farmer Bill Brady discusses his experiences with corn growing at an Extension Field Meeting. Another extension program that served the growers well was the "Greener Pastures" program. This educational effort demonstrated new ways to control weeds, fertilize, and manage pastures and hay crops to help achieve higher milk production. At left, Phil Pierson holds a blue-ribbon sample of red clover hay from his fields near Townsend. This partly explained the record milk production of the Pierson Holsteins. (Courtesy Delaware Agricultural Museum and Village.)

Three

KENT COUNTY

Kent County is the central one of Delaware's three counties. The state capital, Dover, lies in the north central part of the county and represents a demarcation of the heavier coastal plain soils to its north versus the lighter, sandier soils to the south. Most of the county's soils are well suited to a wide range of crops, with the exception of the poorly drained soils on its western boundary and the marshland bordering the Delaware Bay.

The first cannery on the Delmarva Peninsula was Richardson and Robbins, a Dover cannery that opened in 1855. The railroad stimulated fruit and vegetable production for fresh market and supported the canneries by carrying canned goods. Peach and apple production were major enterprises in the county. By the 1930s, more apples were planted per square mile in Kent County than in any other county in the United States. These apples were early summer apples, sold to consumers through the East for homemade applesauce and other baked products. This market diminished as convenience foods developed.

The era after World War II saw the development of the county as a major producer of Irish potatoes. Farm families from Long Island, confronted with the development boom after the war, found Delaware to be almost perfect. The soils were fertile, the potatoes were easily dug, and the region was close to the urban markets. Delaware potatoes, harvested from July through early September, were sold as fresh potatoes to grocery chains from Miami to Boston and into Canada.

The state's two largest farms, each over 10,000 acres, are in Kent County. Charles H. West Farms produces peas, lima beans, spinach, and sweet corn for processing. Schiff Farms produces grain and feeds beef cattle.

An Amish community resides and farms west of Dover. This group settled in Delaware after World War I, moving back east from settlements in Oregon. Dairying, along with corn, hay, and pasture production, characterize the Amish community's farms. However, many of the Amish families rely on significant off-farm income from carpentry, masonry, and other trade skills.

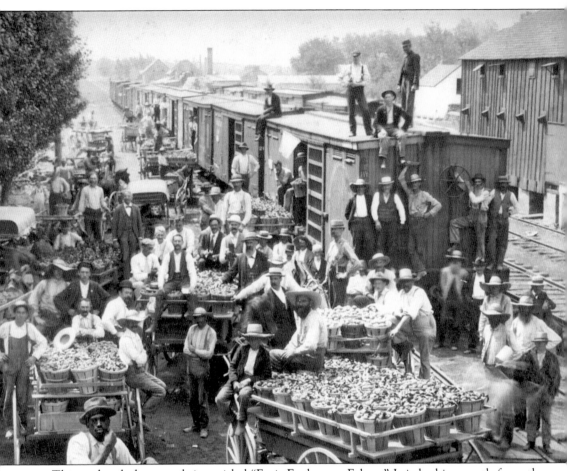

This undated photograph is entitled "Fruit Exchange, Felton." It is looking south from the intersection of Main Street and the railroad. Several refrigerated cars are waiting to be loaded with peaches. The square brick stack in the distance is at the lumber and basket mill. Beyond that mill are the buildings of the cannery. Each stop on the Delaware Railroad was an important shipping point for farmers' produce to markets in the city. Fruit production was an especially important enterprise in Kent County from the years after the Civil War through World War II. (Courtesy Delaware Agricultural Museum and Village.)

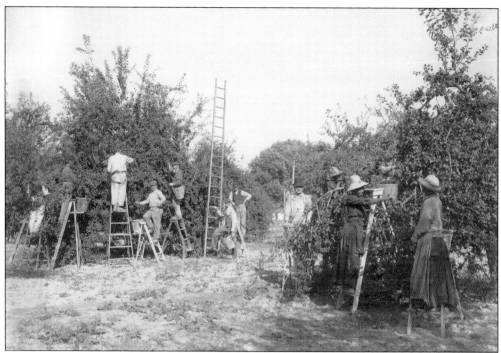

The apple-picking crew above worked on the S. H. Derby Orchard near Woodside. During the 1920s, over 470,000 apple trees were in production in the county. Kent County had more apple trees per square mile than any other county in the country during that decade. Nearly 60 percent of the apples planted in Delaware were in Kent County. Most of the production was early summer apples, known as early transparent apples, which were great for baking and applesauce. Canada was an important market for these cooking apples. Below, wagonloads of apples are being taken into the Derby packinghouse for packing. Both photographs date from the early 1900s. (Courtesy Ruth Walker and S. Derby Walker Jr.)

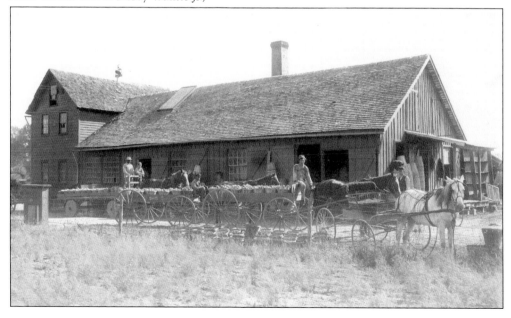

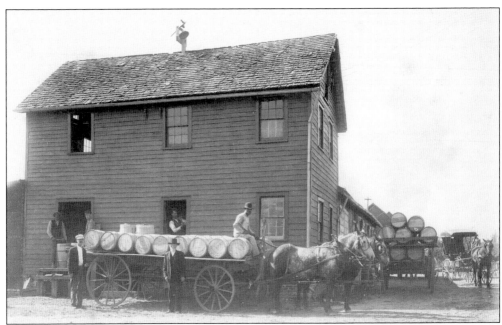

Shown here are three bushel barrels packed by the S. H. Derby Orchard in the early 1900s. Below, women pack apples at the Derby packinghouse. The packed barrels were carried by wagon to the train station in Woodside or Wyoming for shipment to market. Note the bell on the roof to announce work and lunch. S. H. Derby was a prominent fruit grower and active in agricultural societies, and he also served on the University of Delaware Board of Trustees. (Courtesy Ruth Walker and S. Derby Walker Jr.)

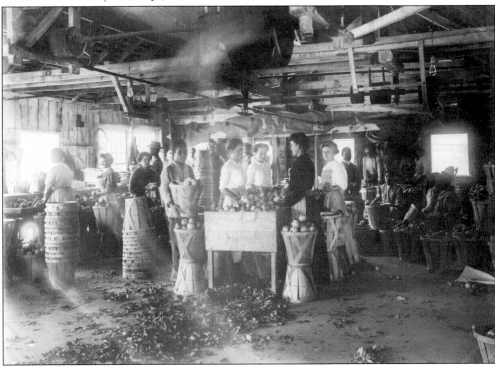

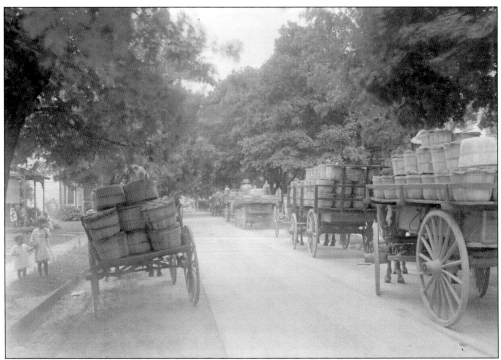

Farmers are lined up to load the crop on the railroad at the town of Wyoming on July 22, 1925. Wyoming, just a few miles south of Dover, was a major apple and peach shipping point. Several fruit brokers operated in Wyoming. Note the apples are packed in bushel baskets. The lower photograph is also at Wyoming, but in this case, peaches are packed in half-bushel baskets. (Above, courtesy Delaware Public Archives; below, courtesy Delaware Agricultural Museum and Village.)

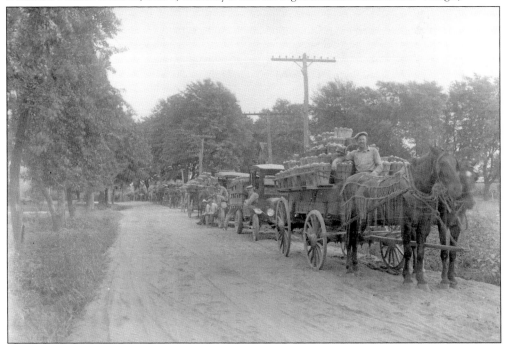

This peach basket is ready for shipping from the J. Allen Frear orchards, and below is his office and supply barn. J. Allen Frear was a prominent farmer and agribusinessman in the first half of the 20th century. The Frear family was involved in fruit growing, fruit sales, and fertilizer and feed sales, and they owned a dairy. The original farm is at Rising Sun, south of the J. Allen Frear Jr. Elementary School. Frear's son, J. Allen Frear Jr., was elected U.S. senator in 1948 and 1954. (Courtesy Delaware Public Archives.)

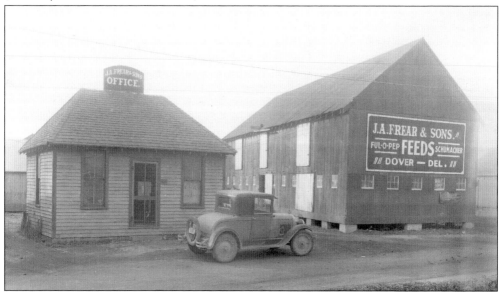

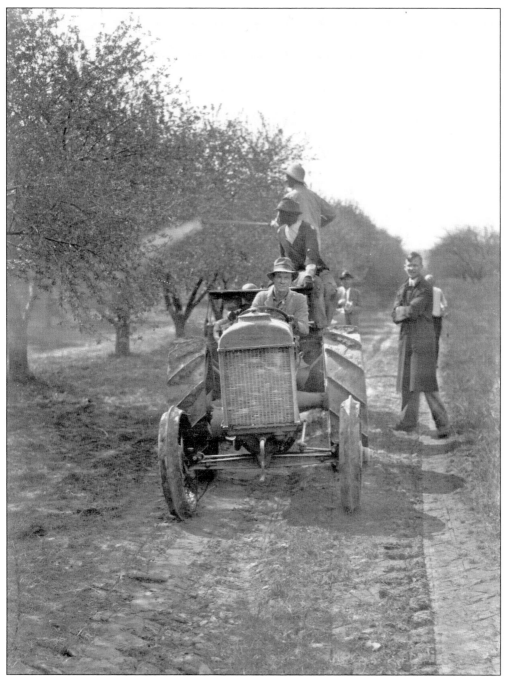

Controlling diseases and insects on fruit was an important battle that raged from the first swelling of the buds in the spring until the fruit was harvested. Various fungus diseases, such as apple scab and brown rot of peach, plagued growers and forced them to spray according to a strict schedule. Insects such as the codling moth on apples and the plum curculio on peaches also required periodic spraying. Most sprayers through the 1940s required a person to stand or walk behind the sprayer with the spray gun. Lead arsenate and various sulfur compounds were the most common pesticides. (Courtesy Delaware Agricultural Museum and Village.)

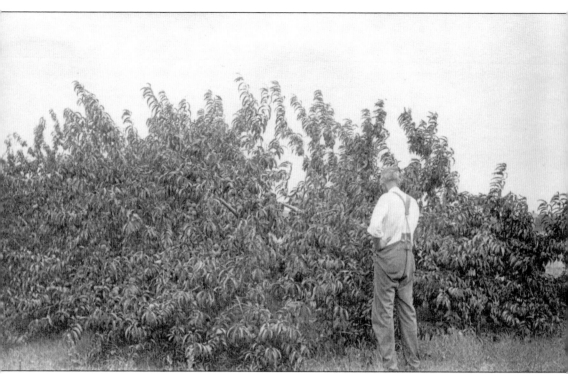

Kent County was also a major producer of peaches through the 1950s. Over two million peach trees were planted in the county in 1890, before the peach yellows disease began to devastate the orchards. By 1935, the county still had 219,749 trees, a nice complement to the large apple industry in the county. At the end of World War II, Kent County had 119,000 apple trees and 150,000 peach trees, making it the center of fruit production in Delaware. This peach tree's bending branches are loaded, perhaps overloaded, with fruit. (Courtesy Delaware Agricultural Museum and Village.)

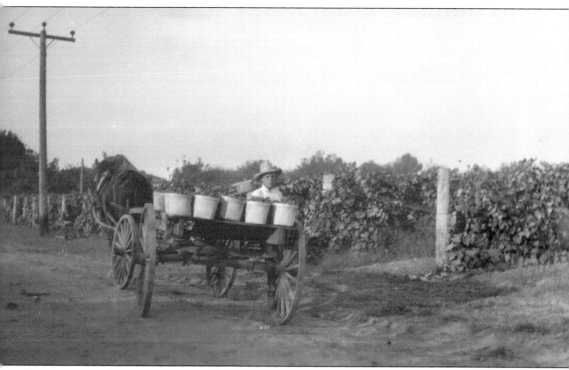

Table grape production was a minor but important enterprise in Delaware. Like the other fruit crops, it was concentrated in Kent County, where the picture above was taken in the 1920s. From 1924 through 1942, nearly 2,000 acres of table grapes were grown in Delaware. They were shipped by rail and truck to consumers in the eastern urban areas that made their own jellies. (Courtesy Delaware Agricultural Museum and Village.)

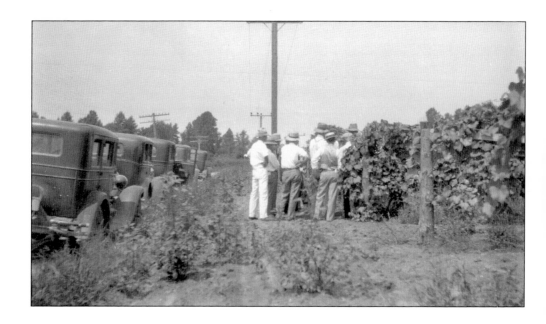

With the widespread adoption of the automobile by the 1920s, farmers enjoyed learning on Cooperative Extension–sponsored tours. The group above is visiting a table grape vineyard in Kent County. Like with all fruit, disease and insect control was a major topic. Spraying for the Japanese beetle and other pests was conducted on a regular schedule through the season. The trio below is hand-spraying in a Kent County vineyard c. 1930. (Courtesy Delaware Agricultural Museum and Village.)

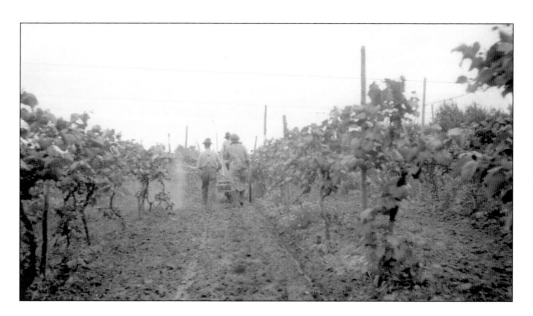

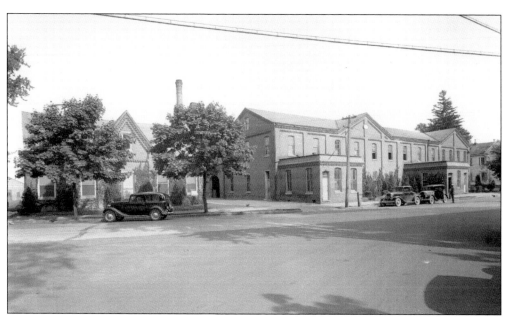

The Richardson and Robbins Company, established in 1855, was the first cannery on the Delmarva Peninsula. The front view, above, facing Kings Highway was taken in 1936. The company canned fruits and vegetables, chicken and other meats, deviled ham, and its specialty, plum pudding. The company was sold to the Underwood Company in 1959 and closed in 1976. The building now houses the state's Department of Natural Resources and Environmental Control. Below is the rear view extended back from Kings Highway. Canning crops became a major agricultural enterprise during the last half of the 19th century and well into the 20th century. Tomatoes, peas, lima beans, sweet corn, and green beans were major cannery crops. (Courtesy Delaware Public Archives.)

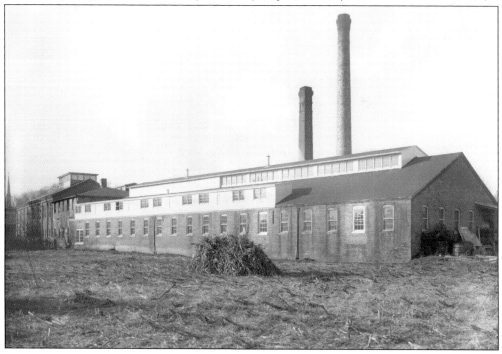

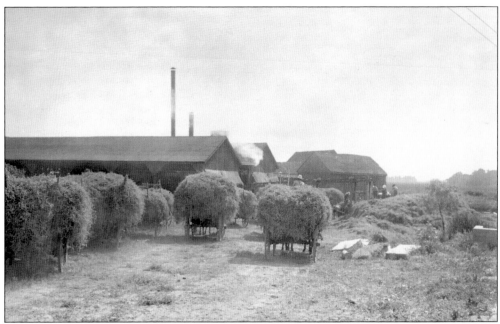

Pea vines are being hauled into the Wm. Numsen and Son cannery near Frederica at the peak of the season, June 15, 1925. The vines were cut in the field with a mower and then loaded onto wagons for transport to the factory. Below, once they arrive at the factory, they were unloaded and pitchforked into the viners that mechanically separated the pods from the vine and shelled the peas from the pod. This company was owned by a Baltimore family that also operated canneries in the city of Baltimore. (Courtesy Delaware Public Archives.)

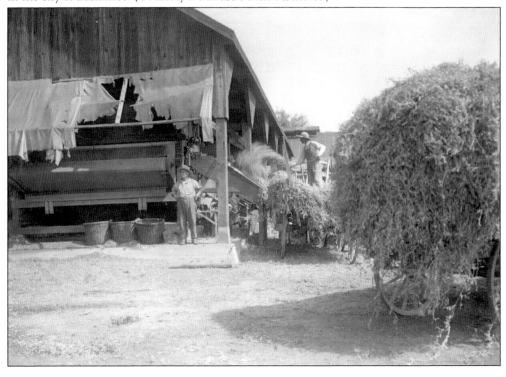

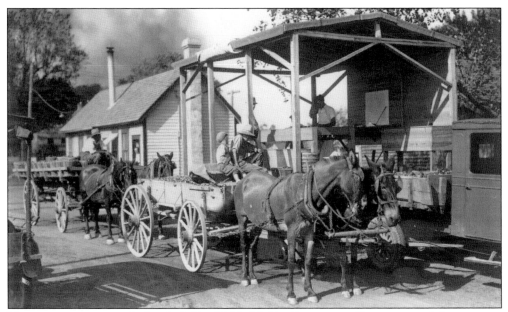

The tomato inspection shed at the Libby, McNeil, Libby Company in Houston served the processor and grower alike to determine the quality of the fruit. Minimum size, absence of defects, and injury-free tomatoes helped determined the farmer's pay and the processor's efficiency. Taken on September 2, 1931, at the peak of the tomato season, this photograph shows a horse and wagon and the truck side by side. Some 17,000 horses and 11,000 mules were still working on Delaware farms in 1931. (Courtesy Delaware Public Archives.)

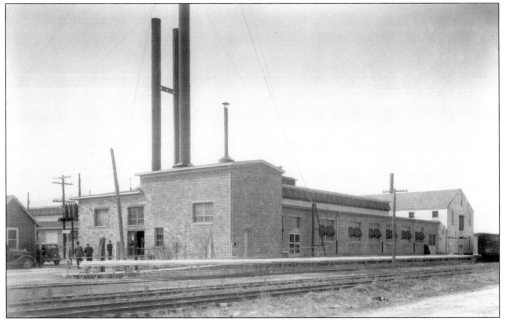

The ability of Delaware farmers to consistently grow high-quality vegetables attracted national canning companies to the state. The Libby, McNeil, Libby plant in Houston, Delaware, pictured here in 1936, operated for over 30 years. Stokely Van Camp, Green Giant, Campbell's Soup, and Vlasic Foods all operated manufacturing plants in Delaware. (Courtesy Delaware Public Archives.)

Hans Stefan, a tomato grower near Rising Sun, proudly displays his 10-ton tomato crop in 1951. Tomatoes were a major processing crop in Kent County. In the 1930s, Delaware farmers planted over 15,000 acres of canning tomatoes annually. By the 1950s, growers in each county participated in the Ten Ton Tomato Club as a way to share the most successful growing practices. (Courtesy Delaware Agricultural Museum and Village.)

One of Hans Stefan's biggest competitors in the Ten Ton Tomato Club was the S. H. Derby and Company in Woodside. Derby's son-in-law, Arthur F., pictured in the middle, is admiring the tomato crop with his son Arthur F. Jr. on the tractor and his other son, Sam. The Walker family continued the Derby family tradition of fruit and vegetable production until 1970. By 1960, the tomato contest goal had risen to the Fifteen Ton Tomato Club. (Courtesy Ruth Walker and S. Derby Walker Jr.)

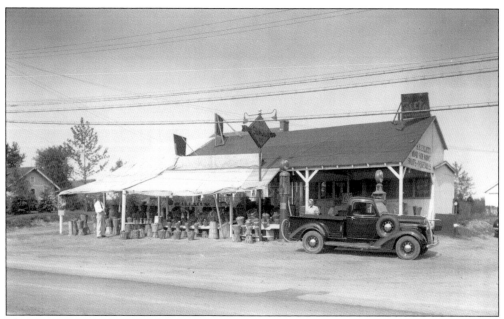

The construction of new roads, coupled with Kent County's fruit and vegetable industry, made roadside farm markets inevitable. Selling directly to consumers allowed farmers to sell at higher than wholesale prices. Many markets were operated by non-farmers, who purchased the fruits and vegetables from local farmers. This market, south of Dover on Route 13, was operating in 1936. (Courtesy Delaware Public Archives.)

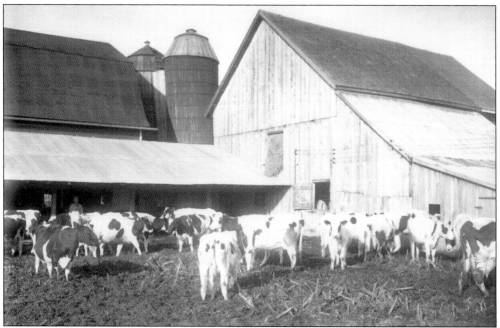

Dairying was an important farm enterprise in Kent County. This is the Holstein herd of J. Harold Schabinger near Felton in 1932. By 1945, more cows were milked in Kent County than the other two counties. The Amish community, who settled west of Dover immediately after World War I, increased the number of dairy cows in the county. (Courtesy Delaware Public Archives.)

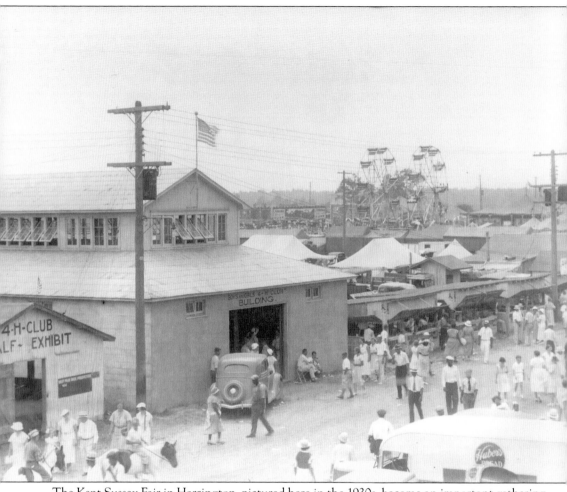

The Kent-Sussex Fair in Harrington, pictured here in the 1930s, became an important gathering place for farmers. Their children exhibited their 4-H projects, competed in livestock competitions, and made lifelong friends with their farm brethren up and down the state. The fair originated from discussions around a potbelly stove in Harrington during the winter of 1919. Thirty acres were purchased for $6,000, and the first fair opened on July 27, 1920. Admission was 25¢ for children and 50¢ for adults. The fair grew and prospered and is now the Delaware State Fair, utilizing over 300 acres and attracting more than 300,000 visitors each year. (Courtesy Delaware Agricultural Museum and Village.)

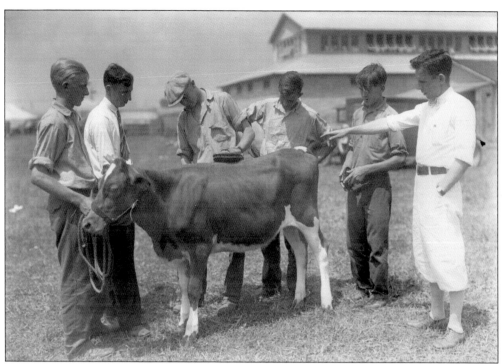

The calf-fitting demonstration above took place at the 1928 Kent-Sussex Fair. Dairying was an important commercial enterprise during this era; over 30,000 cows were being milked in Delaware in 1930. Many farms milked as few as 10 cows and sold the milk daily. Below, Dave Woodward receives an award for showing his Guernsey cow at the fair from George M. Worrilow, director of the Cooperative Extension Service of the University of Delaware in the late 1940s. (Above, courtesy Delaware Public Archives; below, courtesy University of Delaware.)

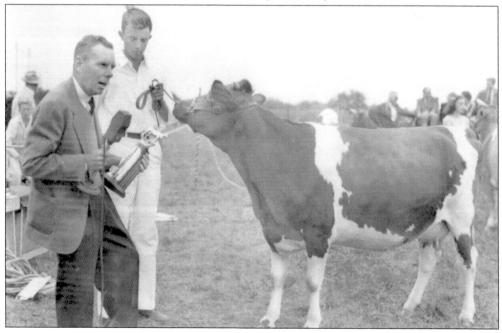

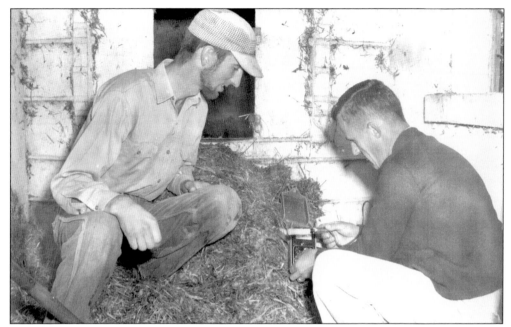

Dr. Bill Mitchell, holding the instrument, and Joe Melvin, a Kent County dairy farmer, check the moisture content and acidity of silage. Mitchell was a mainstay on the agricultural scene for nearly 35 years as the University of Delaware Extension agronomist. In the 1950s, Mitchell and his colleagues worked hard to improve pasture and silage quality by working with farmers in the Greener Pastures program. The dairy industry made huge strides in production. Below is the Ayrshire herd of L. D. Caulk near Woodside in 1932. (Above, courtesy Delaware Agricultural Museum and Village; below, courtesy Delaware Public Archives.)

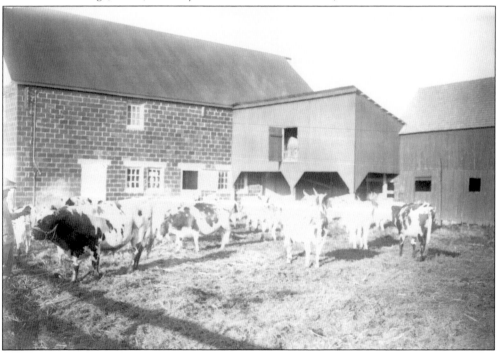

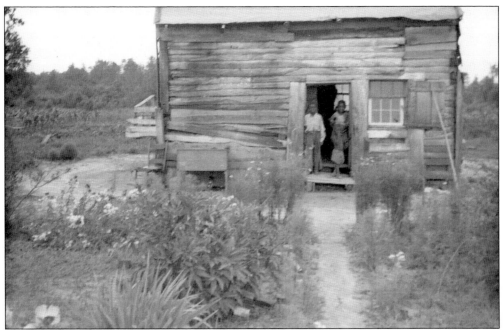

African Americans played an important role in the development of Delaware's agriculture in many ways. A small number were independent farmers. More were sharecroppers. However, for the most part, African Americans were farm workers. Above is a black farm family's home on a Kent County farm in the 1930s. Below, migrant, seasonal workers rest in their quarters on a vegetable farm in the late 1940s. (Courtesy Delaware Agricultural Museum and Village.)

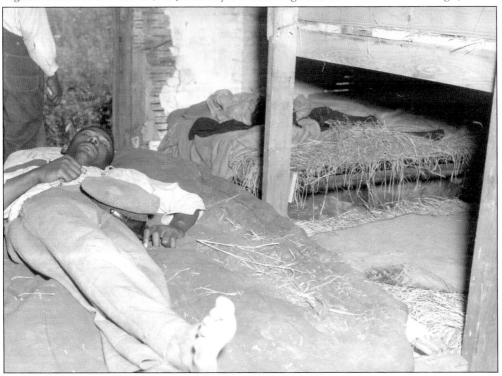

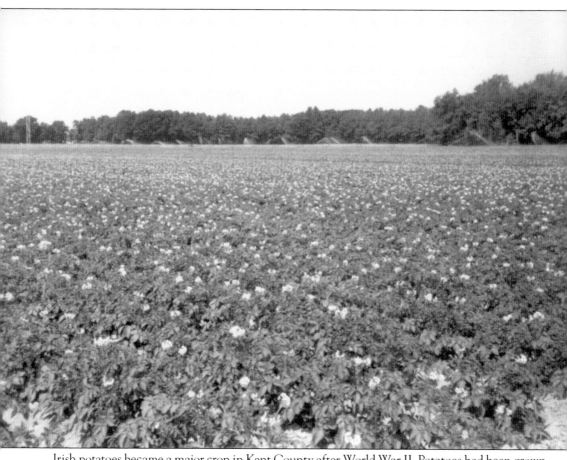

Irish potatoes became a major crop in Kent County after World War II. Potatoes had been grown for local sale and some commercial shipment since the 1860s. World War I stimulated Delaware producers to grow potatoes for that war effort, producing 11,000 acres in 1917. Many farmers dropped potatoes after the war, although 4,000–5,000 acres were produced annually through the 1930s. Christian Zimmerman, a potato grower from near Riverhead on Long Island, New York, visited the Dover area in 1942 to determine the suitability of the area for potato production. Zimmerman encouraged a friend to plant a few potatoes in his garden near Dover, where the crop flourished. In 1944, Christian and his brother Jacob purchased their Delaware farm. Soon dozens of Long Island farmers migrated to Kent County to grow potatoes. By 1960, over 80 producers, most from Long Island but also some native Delawareans, were growing potatoes. (Courtesy Fred and Dan Zimmerman.)

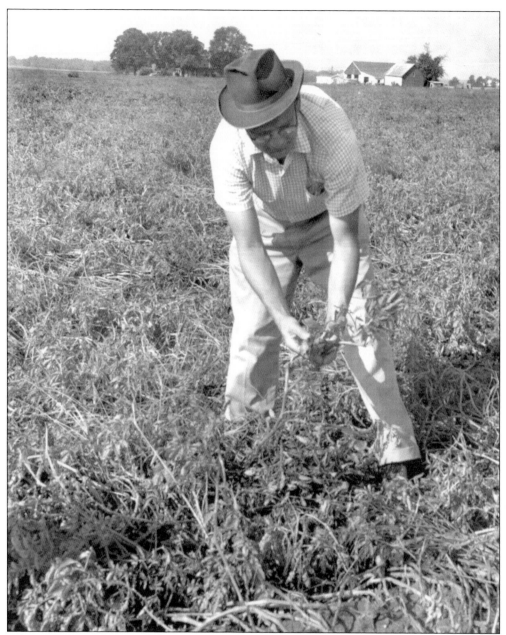

Bob Stevens, University of Delaware Extension horticulturist, examines a field of potatoes damaged by Hurricane Hazel in September 1954. The hurricane occurred after most fields were harvested but caused great losses in unharvested fields. Stevens was another mainstay on the agricultural scene, working to deliver the latest knowledge and information with educational programs for fruit and vegetable producers throughout the state. By 1954, potato growers in Delaware grew over 1.2 million hundredweight of potatoes, generating nearly $3 million in sales. The migration of potato growers from Long Island to Delaware added much to the state's agriculture. Most of the growers settled in Kent County, adding much to the county's economy while creating a potato-based culture that permeated the farming community. (Courtesy Delaware Agricultural Museum and Village.)

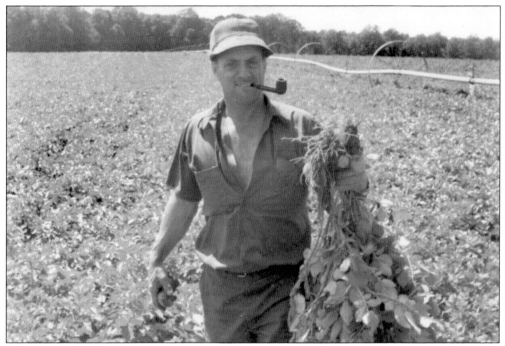

Joseph C. Zimmerman, son of Christian Zimmerman (the first Long Island potato grower to move to Kent County), proudly displays his 1977 crop from one of his fields. Below, he stands by his crop being graded in his packing shed in 1988. The Kent County potato industry was largely based on the round, white potato sold for tablestock or fresh market use. Very few Delaware potatoes were used for chips or processing. Planting begins in mid-March and goes through April. Harvest begins in mid-July and could continue into October, but it typically ends in early September. (Courtesy Fred and Dan Zimmerman.)

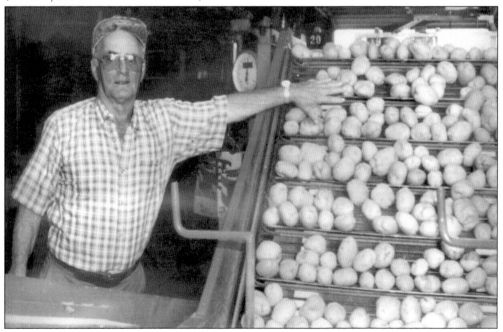

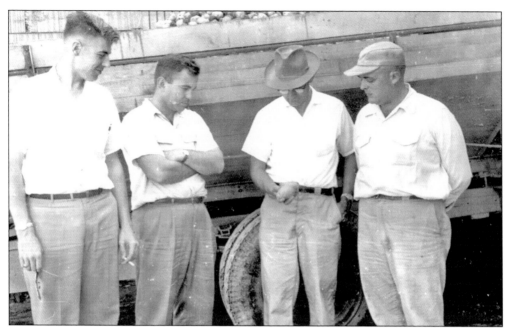

Until the late 1960s, the potatoes were dug from the field with a machine but dropped on the ground to be picked up and put in baskets or burlap bags. They were then hauled into the farmer's packinghouse for grading. Above, these growers and buyers inspect the quality of potatoes handled in a new way, by bulk loading the potatoes directly from the harvester into trucks to carry the crop from the field. Below, the truck in the center is an army surplus truck, retrofitted to be a field truck for hauling potatoes. Many growers were in close proximity to the Dover Air Force Base, which made surplus equipment available. (Above, courtesy Delaware Cooperative Extension; below, courtesy Fred and Dan Zimmerman.)

The potato crop was sold to chain stores, the federal government, and other institutional buyers throughout the eastern United States. A network of Delaware-based brokers was supplemented by seasonal, or "suitcase," brokers, who came in during the season to sell the crop. The photograph shows two brokers working at Delaware Produce Growers, the one grower-owned brokerage in the state. (Courtesy Delaware Agricultural Museum and Village.)

Wilmer "Vinegar Bend" Mizell (left) and Gov. Michael C. Castle flank Joseph C. Zimmerman as they present him with a conservation stewardship award in 1989. Mizell was a former major-league pitcher who served as an administrator in the U.S. Department of Agriculture. (Courtesy Fred and Dan Zimmerman.)

Danny (left) and Fred Zimmerman, third-generation Kent County potato growers with roots that go back to their grandfather's days on Long Island, stand proudly in their potato packing shed. As the Long Island potato farmers moved to Delaware, they established their own packing shed on their farms. Back in Long Island, they took their potatoes to a buyer-owned shed. One farmer, after his first year in Delaware, remarked, "It's amazing how much more yield I get in Delaware," cryptically referring to the cheating that occurred in the buyer sheds back in Long Island. Below, Fred Zimmerman operates a potato harvester that digs and conveys the potatoes on to a field truck. (Courtesy Fred and Dan Zimmerman.)

Brothers George and Howard Papen moved from northern New Jersey to their farm just west of Dover in 1952. Pictured above in the 1960s from left to right are Jack Walton, Richard Papen, Howard Papen, George Papen, and Jack Papen. The family grows cabbage, sweet corn, and green beans. They hydrocool, pack, and ship their products to chain stores and other buyers all over the eastern United States. It is not unusual for them to load 25 trailers of produce per day during the peak of the season. Below, the family members involved in the operation in 1990 are, from left to right, (first row) Howard, Kenny, Jack, Carol, Evy Papen Cuthrell, Mary, George, and Richard; (on the tractor) Greg, Jeff, Janet Papen Myers, and Tony Kaczka.

Four

SUSSEX COUNTY

Sussex County is the southernmost and largest of Delaware's three counties. Nearly 49 percent of Delaware's land mass is in Sussex County. Part of the coastal plain, the soils tend to be light, sandy, and well drained. They are not as fertile and tend to be droughtier than the soils in northern Kent and throughout New Castle County. Ninety-three percent of Sussex County's soils are suited for farming. The rest is marsh, wetlands, and beach.

Many of the county's first farming settlers migrated east from Maryland and Virginia as tobacco depleted the fertility of their soils. Settlement of the county was relatively slow, as was agricultural progress during the years before the Civil War. As the railroads penetrated down to Delmar on the state's southern boundary, and then crossed the county connecting farmers to distant markets, Sussex farmers became producers of fruits and vegetables.

Reaching markets was one challenge, but the natural wetness and sandiness of its soils still remain the overall limitations for farming. Nearly 45 percent of the acreage for farming requires some artificial drainage. A similar percentage of the land is moderately or severely limited by sandiness and low available moisture capacity.

Drainage of the fields by ditching, commonly called tax ditches, has enabled crop production on poorly drained lands. The tax ditch system has been important to the livelihood of farmers since the 1930s when the Soil Conservation Service fostered the system. Irrigation, beginning in the 1950s, has overcome the low moisture holding capacity of the county's sandy soils. The standard method of irrigation is from center pivot systems. Corn, a staple for poultry feed, is the most widely irrigated crop in the county. Nearly 70,000 acres of grain and vegetables are irrigated today.

The rise of the broiler chicken industry is the single biggest development in Sussex County's history. From that accidental experiment of Mrs. Steele's chickens in 1923, the county today has over 3,000 chicken houses, or 75 million birds being raised at any one moment. The development of the industry was enhanced by the construction of the DuPont Highway in the 1920s, connecting the county to the markets of the north.

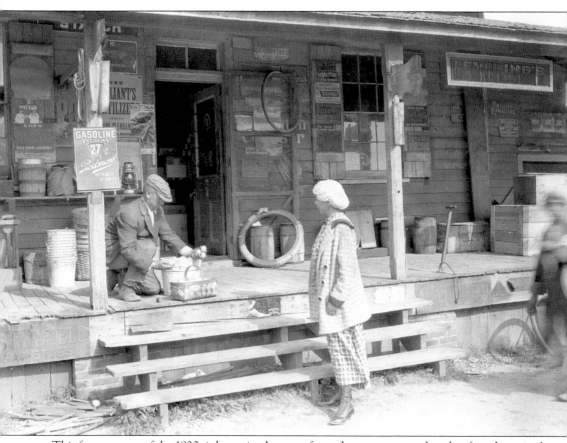

This farm woman of the 1920s is bartering her eggs for cash money or merchandise from Levering's store near Argo's Corner in Sussex County. Gasoline is 27¢ a gallon, air for tires is free as long as one can pump it, and the signs advertise a multitude of products. The sign to the left of the door advertises Valliant fertilizer and the local merchant who sells it, Frank Clendaniel of Lincoln City. The Valliant fertilizer company would later be led by a future governor of Delaware, Bert Carvel. Country stores across the county were not only sources of merchandise but of news, gossip, and fellowship in an era before mass communication and rapid travel. (Courtesy USDA.)

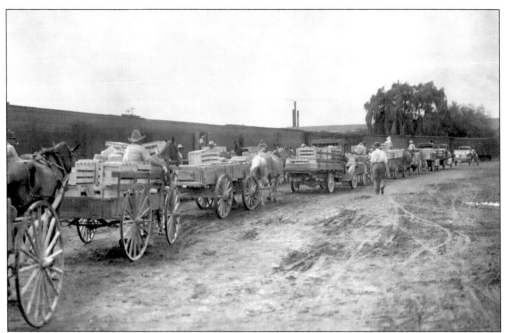

Cantaloupes and watermelons grow especially well on the light, sandy soils in the southwestern part of Sussex County near the towns of Delmar, Laurel, and Seaford. The Pennsylvania Railroad ran down the spine of the Delmarva Peninsula and had a station at each town. Above, farmers were lined up to load cantaloupes at Seaford on August 25, 1928. Below, the watermelon lineup on August 19, 1928, at Laurel also illustrates the principle of assembling the production of many farmers into a volume that is economically practical for shipping. (Courtesy Delaware Public Archives.)

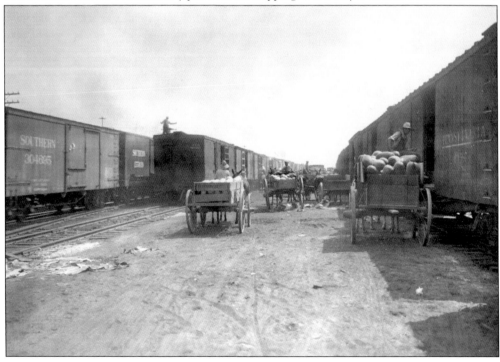

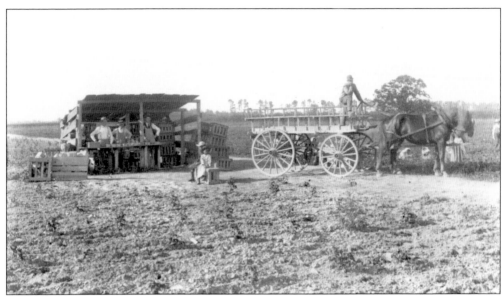

Strawberries were an important cash crop throughout the county. Thousands of quarts were shipped each year from Selbyville, Milford, Delmar, Laurel, Seaford, and Bridgeville. Ripening in May and June, the crop provided cash to farmers and pickers early in the summer. The strawberries above were being picked and packed at the J. R. Roosa farm near Milford in 1896. (Courtesy Delaware Agricultural Museum and Village.)

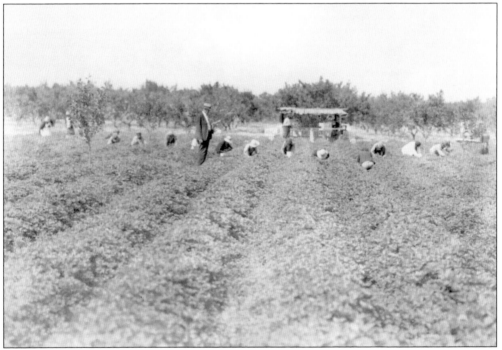

This crew is picking strawberries at the O. A. Newton farm near Bridgeville on May 28, 1935. That year, Delaware strawberry growers harvested 83 crates per acre on 4,900 acres. Twenty-four quarts were in each crate. They received $2.10 per crate, generating $855,000 of farm income. Pickers received between 3¢ and 5¢ per quart. (Courtesy Delaware Public Archives.)

O. A. Newton is holding a box of fancy strawberries in his field. He and his son Warren established a farming and agribusiness company that continues today. Warren became a pioneer in many agricultural enterprises, perhaps especially so in the poultry business. In addition to growing fruit and vegetables and raising poultry, the firm became involved in poultry processing, farm machinery sales, and grain handling equipment. (Courtesy Delaware Public Archives.)

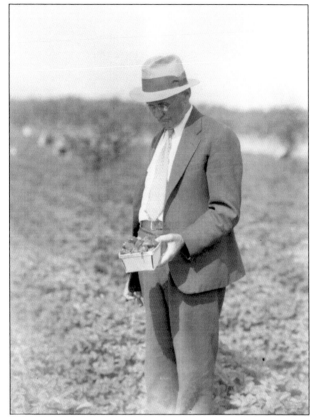

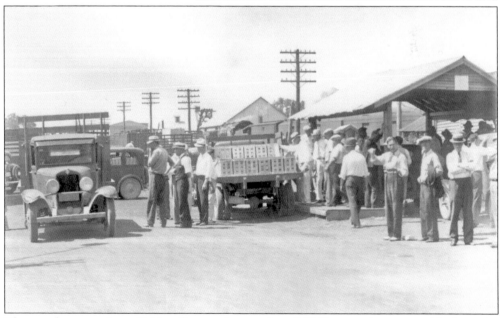

The strawberry auction at Bridgeville, seen here on June 7, 1935, was an important shipping point that became well-known throughout the East. A total of 407,000 crates of strawberries were shipped from Delaware in 1935, or 9,768,000 quarts. (Courtesy Delaware Public Archives.)

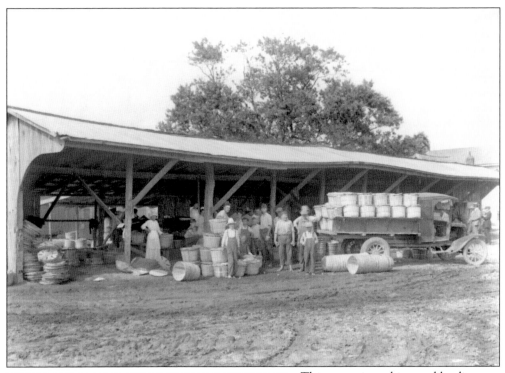

This group is packing and loading apples at the O. A. Newton orchards in the 1920s. Apple and peach production was important in Sussex County and rivaled Kent County. Indeed, from 1890 until 1920, more apples were grown in Sussex. (Courtesy Delaware Agricultural Museum and Village.)

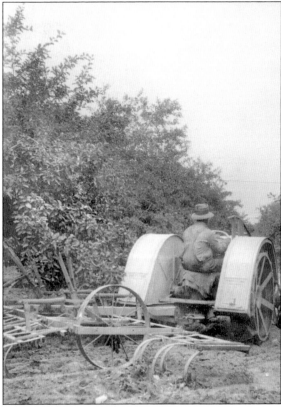

Nelson Draine operates a steel-wheeled tractor to harrow weeds in the row-middles at Nassau Orchards, Inc., near Lewes in the 1930s. Nassau Orchards was an important peach and apple shipper for over 70 years, from 1920 to 1990. In the early years, it shipped its fruit on the Pennsylvania Railroad. The company pioneered modern roadside farm marketing in the 1950s. (Courtesy Halsey G. Knapp.)

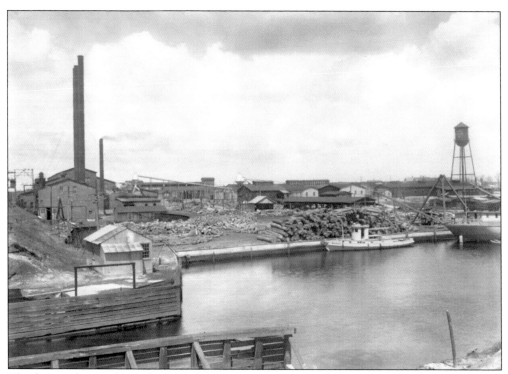

The fruit and vegetable industry in Sussex County stimulated the important industry of basket manufacturing. Baskets of all sizes, from one bushel down to one pint, were made in Sussex County from local timber. The Marvel Package Company, pictured here in 1935, operated on the banks of Broad Creek in Laurel. Below, the company's 5/8 bushel baskets are set out for drying after manufacturing. (Courtesy Delaware Public Archives.)

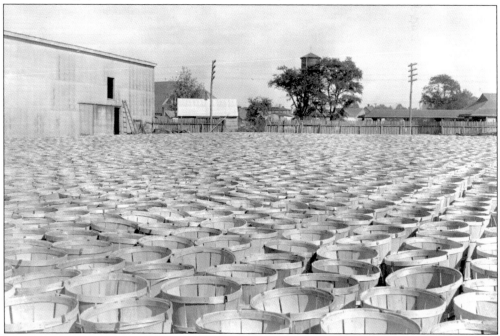

Wilson Phillips (in back) and James Bacon assemble cantaloupe crates at the CCA packinghouse near Delmar in 1938. Farmers would often buy the components and assemble the crates themselves to save money. Below, the Layton and Owens Manufacturing Company in Bridgeville was an important maker of baskets and crates. (Courtesy Delaware Agricultural Museum and Village.)

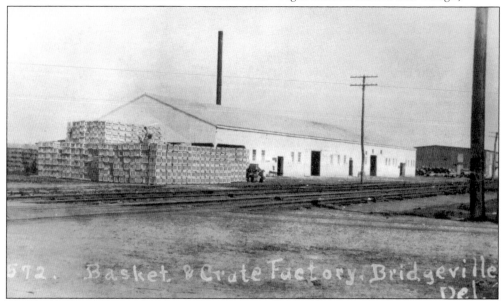

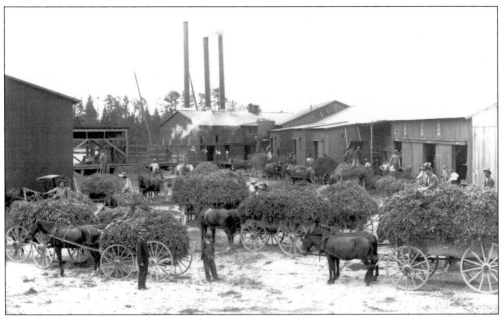

The canning industry in Sussex County arose after the Civil War and became a major stimulus to the economy. Fertile soils, productive farmers, ambitious canners, and the transportation link via the railroad and later the highway set the stage for the growth of the industry. Farmers hauling pea vines to the Greenbaum Brothers factory in Seaford for shelling in June 1904 are pictured above. (Courtesy Delaware Agricultural Museum and Village.)

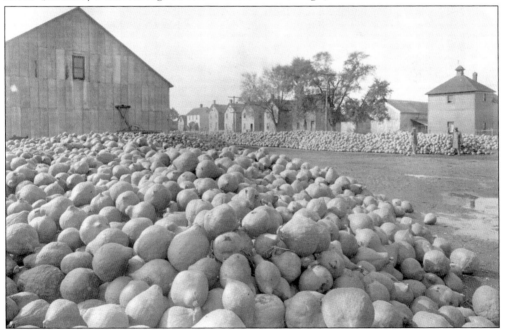

Five hundred tons of pumpkins are piled up for canning at the H. P. Cannon and Sons factory in Bridgeville during the fall of 1923. The Cannon firm operated from 1881 to 1981, canning peas, tomatoes, string beans, lima beans, squash, pumpkins, and peppers along the way. (Courtesy Delaware Public Archives.)

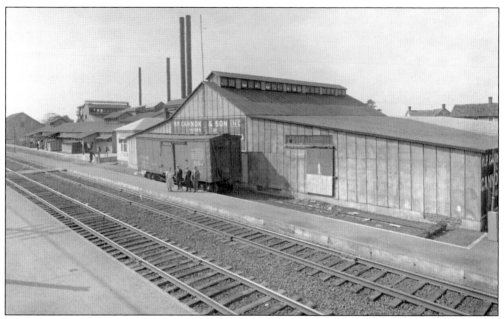

The H. P. Cannon canning factory in Bridgeville, like all canning factories, was situated on or very near the railroad. James Cannon settled in the area of the Nanticoke River in 1682, and the family remained in the region as active farmers and merchants. William Cannon was the governor of Delaware during the Civil War. His sons, Henry and Phillip, started canning peaches in 1881 to develop an alternative outlet during market gluts. (Courtesy Delaware Public Archives.)

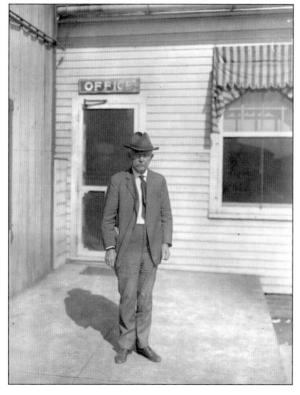

Henry P. Cannon stands in front of his office in 1923. His son, Harry Cannon, and grandson, Henry P. Cannon II, would lead the company until it closed in 1981. Cannon Foods became the nation's leader in canned sweet peppers by the 1950s. (Courtesy Delaware Public Archives.)

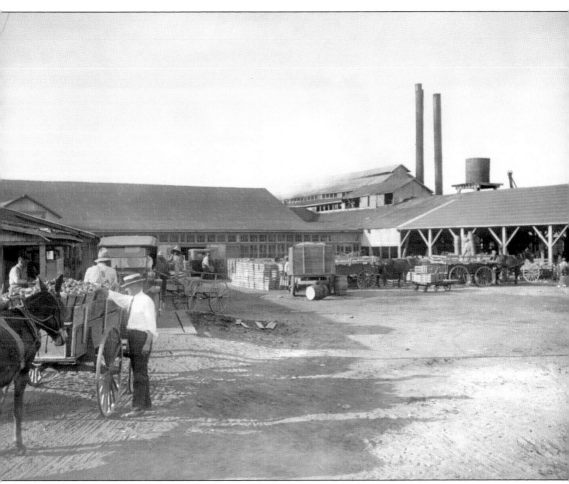

John G. Townsend Jr., pictured on page 22, owned this cannery in Selbyville. Townsend also owned canneries in Georgetown and Rehoboth Beach. In the 1920s, the company canned strawberries, apples, pears, tomatoes, tomato pulp, catsup, chili sauce, string beans, and sweet potatoes. Today J. G. Townsend Jr. and Company, Inc., operates in Georgetown and commercially freezes peas and lima beans. Many canners switched to freezing after World War II. (Courtesy Delaware Public Archives.)

The shelling operations for peas and lima beans moved away from the factory to viner stations located near the fields. The machinery that separated the pods from the vines and shelled the peas from the pods, known as viners, saved the labor of 200 people for each acre. Moving this operation closer to the fields created efficiencies by reducing the transport of large quantities of vines to the factory. Only the peas or beans were transported to the factory once vined. The large quantity of "tailings" as a by-product of the operation is illustrated in the top photograph, taken in 1929 near Harbeson. Below, this viner near Milton is operated by steam engine in 1935. (Courtesy Delaware Public Archives.)

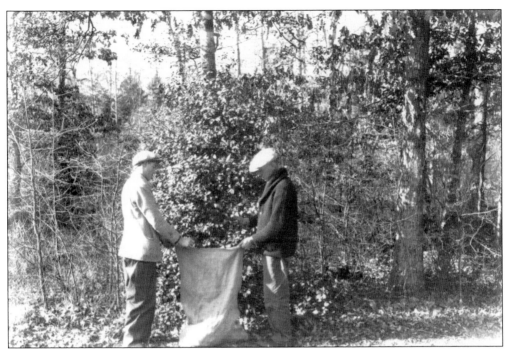

While an industrialized agriculture evolved with the canning industry, and a commercial market system evolved with the fresh market fruit and vegetable industry, many Sussex County farmers supplemented their incomes by collecting holly from their woods and making wreaths and other Christmas decorations from the native plant. These men are collecting holly near Ellendale. Their products are displayed at right. (Courtesy Delaware Agricultural Museum and Village.)

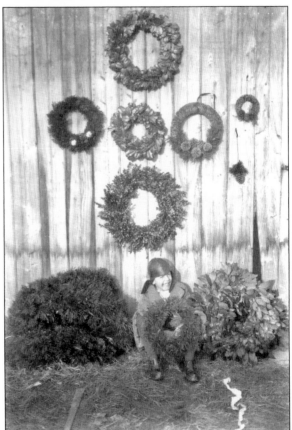

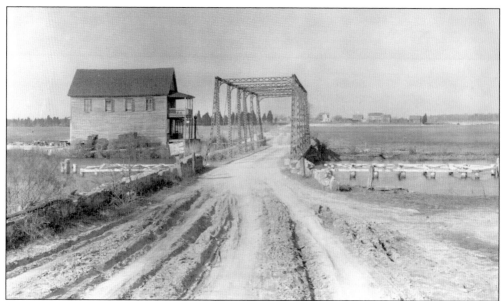

All Sussex county farmers in the 1920s faced tough road conditions. Above is the road to the Broadkill Bridge from the south, on December 18, 1925. At that time, the road was dirt from Dover all the way to Lewes. The State of Delaware initiated a program in the 1940s with the goal to pave all dirt roads, entitled the "Farm to Market" program. (Courtesy Delaware Public Archives.)

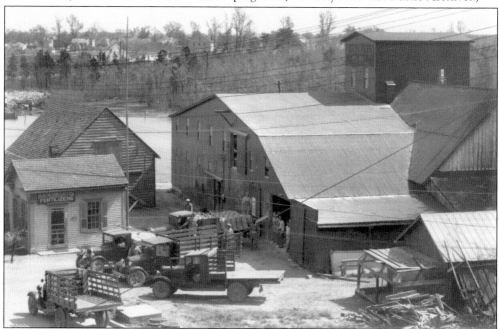

The A. S. Wooley Company in Seaford, pictured here in 1935, supplied manufactured fertilizers to farmers. As Sussex County farmers began to see more income from their fruit and vegetable crops, and from the rapidly expanding poultry industry, they were able to purchase manufactured fertilizers. The use of poultry manure and fertilizers helped corn, wheat, and other crop yields improve. Corn was critical to poultry feed, and corn yields increased with manure applications. (Courtesy Delaware Public Archives.)

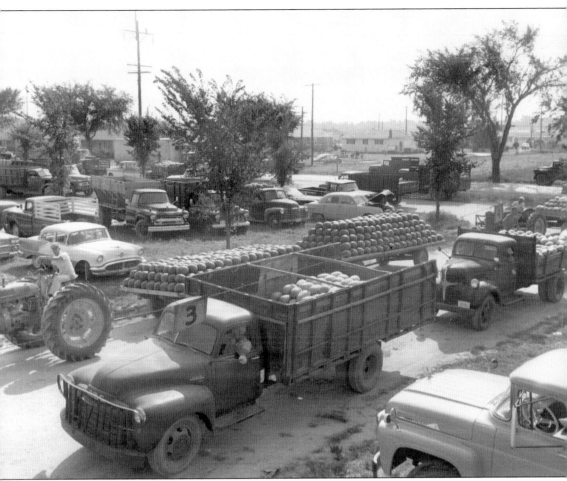

Farmers are lined up for the produce auction at the Southern Delaware Truck Growers Association's Laurel Auction Market, c. 1960. The market was started in 1940, with 213 farmers putting up $5 apiece to form the organization. Since then, the market has sold over $3 million of produce. The market has been an important part of the community since its founding and reflective of the tradition of watermelons and other truck crops in the southwest Sussex region. (Courtesy Southern Delaware Truck Growers Association.)

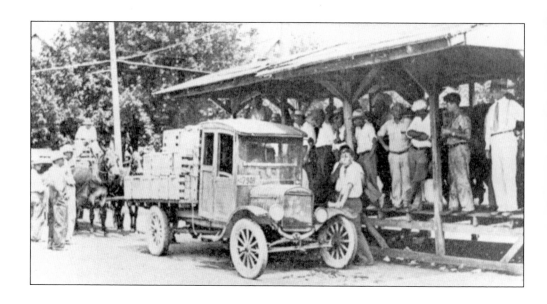

Auctioning watermelons and other produce goes back to the 1920s in Laurel. The small shed above was an auction or a buying station at Poplar and Clayton Streets. The Laurel Produce Association, below, was located on DaShields Street, just south of Eighth Street. This was a buyer-owned auction that operated during the 1920s and 1930s. (Courtesy Delaware Public Archives.)

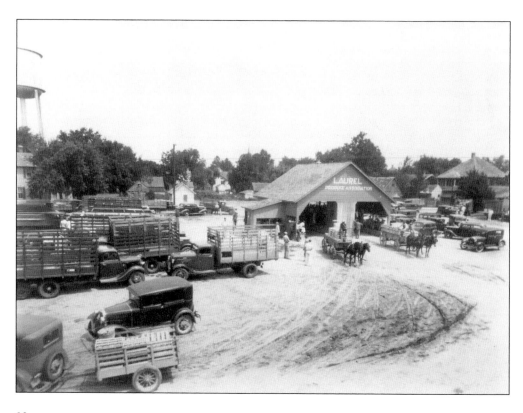

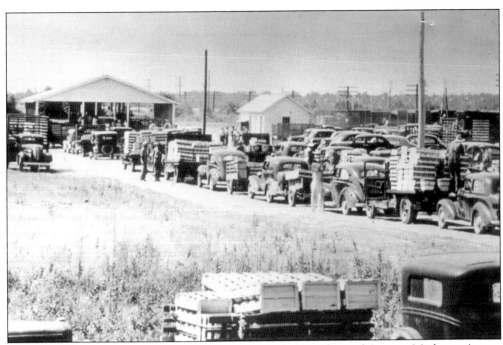

Farmers bring cantaloupes packed in crates to the newly formed Laurel Auction Market in August 1940 at the Tenth Street location. Note the combination of trucks, wagons, and cars used to deliver the produce. The original shed and building pictured above are still in use in the current location at the intersection of Route 13 and Route 9. This location, which opened in 1955, is pictured below. (Courtesy Southern Delaware Truck Growers Association.)

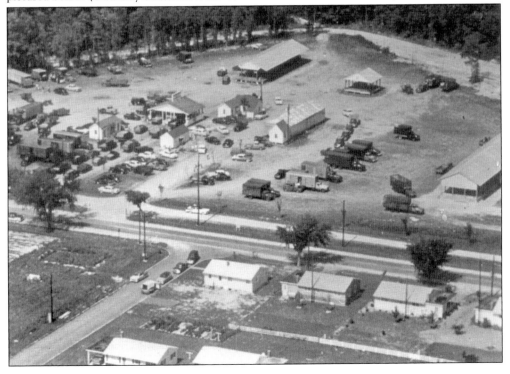

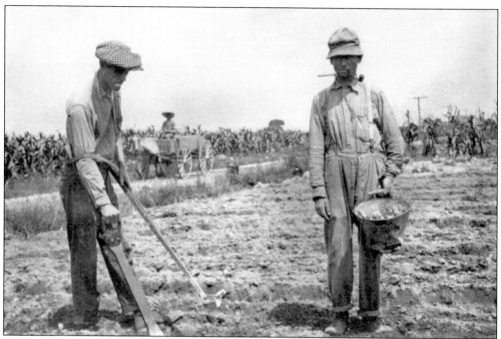

These two farmers are transplanting sweet potatoes in 1915 near Lincoln. The implement used by the man on the left helps with transplanting. Vegetables were grown in gardens for family use on every farm, for sale at local stores, and on a larger scale for shipment to urban markets. (Courtesy Delaware Cooperative Extension.)

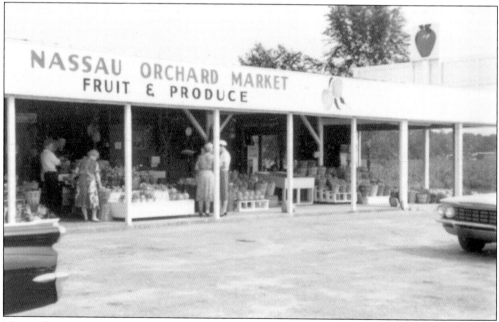

Nassau Orchard Market was the premier roadside market on the way to the beach for over 30 years. Nassau Orchards, Inc., developed the market near Lewes in the 1950s as a new enterprise for their orchard business. Halsey G. Knapp established the market to capture the emerging consumer base related to the beach resorts of Lewes and Rehoboth. (Courtesy Halsey G. Knapp.)

Leslie G. Knapp holds a prize cantaloupe in front of his son's produce market in 1970. Nassau Orchards, Inc., was owned and operated by Knapp and his son, Halsey G., from 1921 until Halsey's retirement in the early 1990s. Leslie G. Knapp came to Delaware as the assistant manager of the company in 1920. Nassau Orchards was started with the private investment of a group of officers of the Pennsylvania Railroad Company in 1916. Knapp was well respected and successful, eventually buying the company from the original investors. (Courtesy Halsey G. Knapp.)

The Supplee-Willis milk station at Nassau in 1928 was established for the dairy farmers in the Lewes-Rehoboth area. They had no ready market for their milk before this rail shipping point was established in the 1920s. The county agent, Molloy Vaughan, worked with the farmers and the Supplee-Willis Company to establish a daily milk express from Nassau to the company's plant in Philadelphia. The frame building behind the milk station was the apple packinghouse of Nassau Orchards. (Courtesy Delaware Public Archives.)

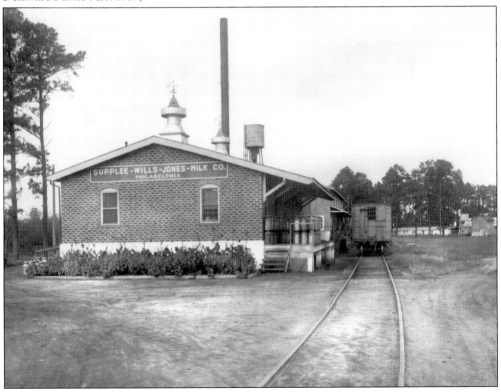

Dairy farming was important to Sussex County. William Hopkins, near Lewes, looks with satisfaction at the seal on a temporary silo made with baled straw walls, plastic, and other innovations in the early 1960s. Hopkins, now in his 80s, still works on the farm with his son Walter and his grandson Burli. They milk over 500 cows. (Courtesy Delaware Agricultural Museum and Village.)

Turkeys were grown on the open range in Sussex County. This farmer proudly displays one of his birds. Through the 1940s, state turkey producers raised and sold approximately 100,000 birds per year. Today one producer still raises turkeys, offering fresh turkey in time for Thanksgiving and Christmas. (Courtesy Delaware Agricultural Museum and Village.)

Pork production was an important enterprise in Sussex County until the 1990s. Many farms had a farrowing house where the pigs were born, and then the farmer put them out on fields once they were weaned. In 1945, some 41,000 hogs were sold at $14 per hundredweight. The consolidation of the meat industry in the 1990s reduced the number of producers. (Courtesy Delaware Agricultural Museum and Village.)

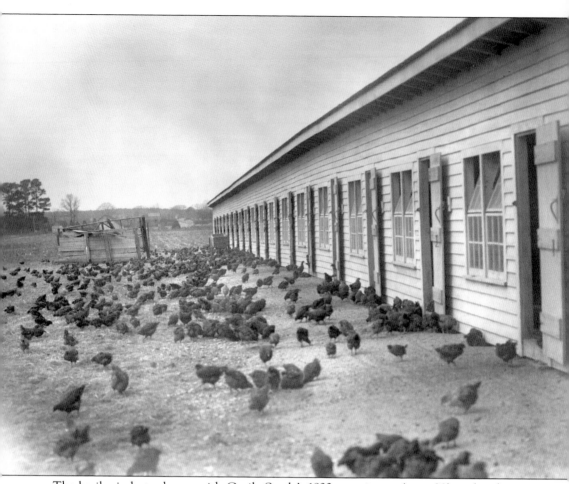

The broiler industry began with Cecile Steele's 1923 experiment (page 20) on her farm near Ocean View. She and her husbanded expanded their broiler business and used larger houses to raise her birds. This is one unit pictured on March 3, 1936, thirteen years after her first flock. (Courtesy Delaware Public Archives.)

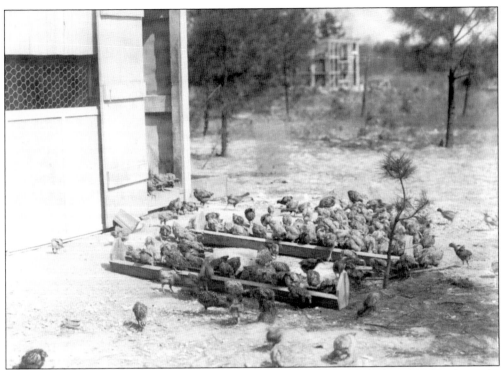

In the beginning of the industry, farmers would let their broilers leave the house and feed outside. As demand for broilers increased, farmers began to raise the birds year-round in enclosed buildings. The rate of growth and feed efficiency also increased, which, when coupled with its proximity to urban markets, gave Sussex County poultry producers a significant competitive advantage over the other regions. (Courtesy Delaware Agricultural Museum and Village.)

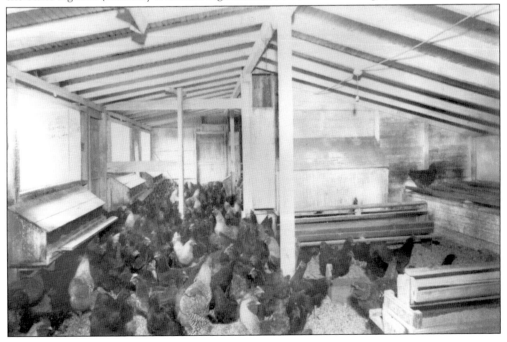

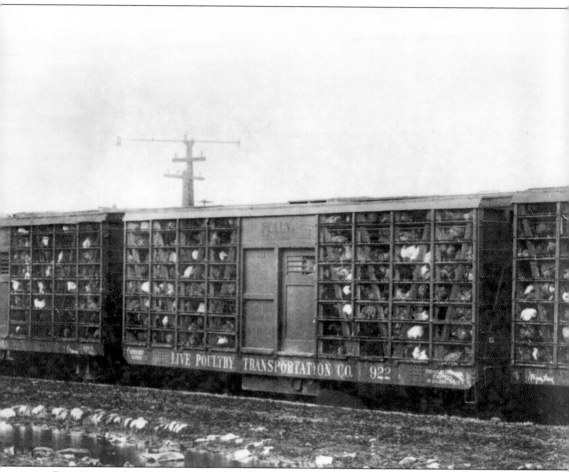

For 15 years after the beginning of the broiler industry in 1923, the mature birds were hauled live to markets in Philadelphia, New York, and other cities. Usually hauled by truck on the newly completed DuPont Highway, occasionally they were taken by rail as is this load in 1932. John S. Isaacs, a large poultry producer near Milton, shipped live birds all the way to Missouri in the 1930s. He sent an employee on the train to feed the chickens while they traveled. (Courtesy Delaware Public Archives.)

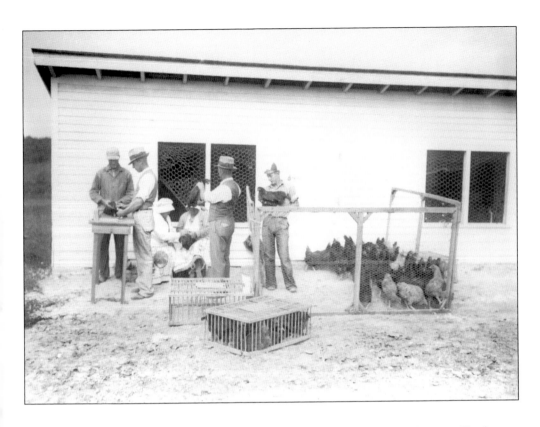

Poultry health became an important aspect of the industry as higher populations of birds were kept in confined areas. Often ideal conditions for epidemics through flocks of birds existed. An important part of monitoring health was screening through blood testing, shown here at the Steele farm in 1936 above. Below, the technicians are screening for laryngotracheitis in 1935. (Courtesy Delaware Agricultural Museum and Village.)

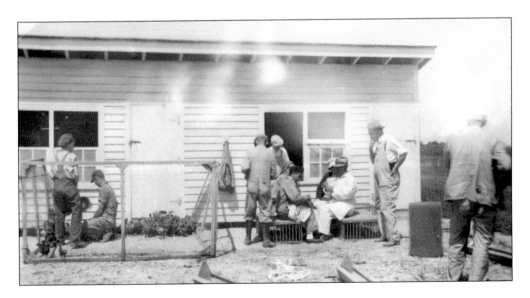

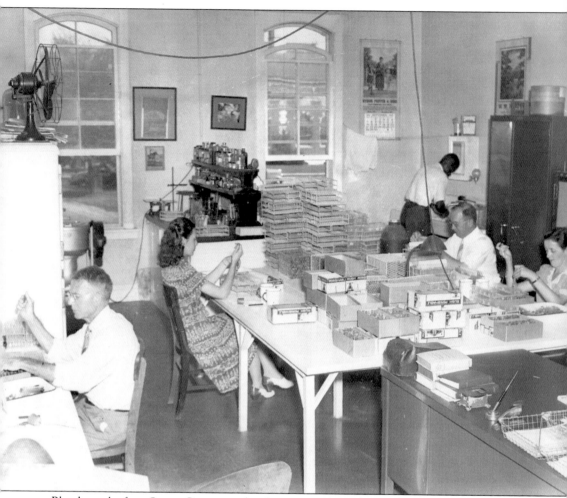

Blood samples from Sussex County poultry farms were often taken to the State Board of Agriculture laboratory for testing. Dr. H. R. Baker, seated at right, set up test tubes with his staff to test for the Pullorum disease in 1941. William Horsey (left), Violet Bringhurst, and Helen Melvin (right) assist. Aide Clarence Stevenson is washing the test tubes. (Courtesy Delaware Agricultural Museum and Village.)

The modern incubator shown above from Steen's Hatchery in Dagsboro was typical of the 1930s. The industry consisted of several independent functions operating as separate businesses. The hatchery man provided the chicks, the feed man provided the prepared feed, which was hand-fed by the farmer, and the farmer looked after the growing broilers. Below, an early attempt to control temperature in the chicken houses was an important step towards improving the birds' environment. (Courtesy Delaware Agricultural Museum and Village.)

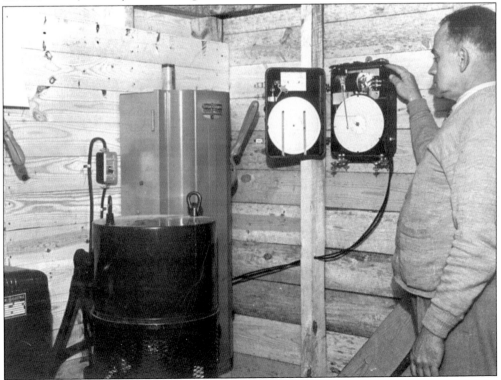

In the days before an integrated industry, marketing was left to the individual growers. One important market was the Eastern Shore Poultry Exchange near Selbyville. Farmers brought sample birds to the auction, where qualified, approved buyers from the processing companies would bid. The auction was so critical that it was broadcast daily on local radio. At its peak, it sold 47 million birds per year. The exchange opened in 1952 and operated until 1969. As processors integrated the hatchery and feed, health, and marketing functions, the need for the exchange declined. By the late 1960s, most of the birds were grown on contract with a processing company. (Courtesy Delaware Agricultural Museum and Village.)

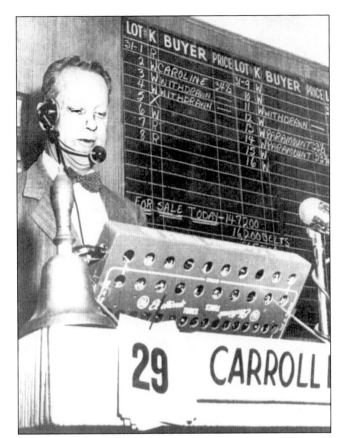

Carroll Long served as the auctioneer at the Eastern Shore Poultry Exchange, which operated every day at 11:00 a.m., Monday through Thursday. In 1958, 70 percent of the region's broilers were sold at the exchange. Below, the buyers pay rapt attention to Long's auctioneering. (Courtesy Delaware Agricultural Museum and Village.)

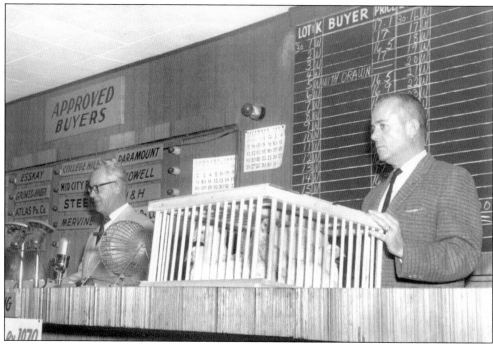

The daily auction begins with Carroll Long at the microphone, while his assistant handles the chicken coop. Below, the auction results are posted on the board for all to see. (Courtesy Delaware Agricultural Museum and Village.)

LOT#	K	BUYER	PRICE	LOT#	K	BUYER	PRICE	LOT#	K	BUYER	PRICE	LOT#	K	BUYER	PRICE
1-1	W	SWIFT	17¾	11-16	W	WITHDRAWN	—	11-31	R	SWIFT	19	11-46	W	SHOWELL	20¼
2	W	SELLER	—	17	R	SELLER	—	32	R	SELLER	—	47	W	H&H	20
3	R	SWIFT	18¾	18	W	SELLER	—	33	R	SWIFT	18¾	48	W	ARMOUR	20
4	W	SELLER	—	19	X	ALLIED	14	34	W	SWIFT	18½	49	W	SELLER	—
5	X	ALLIED	15¾	20	W	MILTON	19¾	35	R	ALLIED	18½	50	R	MILTON	19½
6	X	PARAMOUNT	16	21	W	ALLIED	20¾	36	R	SWIFT	18¾	51	W	SHOWELL	21
7	W	SELLER	—	22	W	SWIFT	19¾	37	W	H&H	19½	52	W	PARAMOUNT	20½
8	R	SWIFT	18½	23	W	SWIFT	19¾	38	X	SELLER	—	53	W	ARMOUR	20¾
9	W	SHOWELL	19½	24	W	SWIFT	18½	39	W	SWIFT	20	54	W	SELLER	—
10	W	ALLIED	18¾	25	R	H&H	20	40	R	SWIFT	20	55	W	SELLER	—
11	X	SELLER	—	26	R	H&H	20	41	W	SELLER	—	56	W	SELLER	—
12	W	SWIFT	19½	27	W	SWIFT	19¾	42	X	PARAMOUNT	15¾	57	W	MERVINE	20½
13	B	MILTON	39¾	28	W	ALLIED	20¼	43	X	H&H	19				
14	W	SWIFT	19	29	X	PARAMOUNT	19¼	44	X	PARAMOUNT	19¾				
15	W	ALLIED	17¾	30	W	PARAMOUNT	20¼	45	X	PARAMOUNT	18¾				

FOR SALE TODAY— 438,900
6,500 BELTS
FOR SALE MONDAY— 74,000

CONTRACT TIME— WED. DEC. 16

The auction board at the Eastern Shore Poultry Exchange on December 11, 1966, displays the lot identification for each farmer, the selling price, and the buyer for each lot of birds. That day, 438,900 birds were sold. Once the deal was done, the birds were moved from the farmer's chicken house to the processor with the winning bid. The buyers had to pay in full within five days of the transaction. (Courtesy Delaware Agricultural Museum and Village.)

The emergence of the poultry industry from the 1920s through today was aided by cooperation between all components of the industry and dedicated poultry workers at the University of Delaware and other agencies. These four men from Sussex County were attending a 1925 poultry convention in Atlantic City, New Jersey. From left to right, Hoke Palmer (extension poultry scientist), Molloy Vaughan (Sussex County agent), Ray Motney (hatcheryman), and Byron Pepper (hatcheryman) have some fun on the boardwalk. (Courtesy Delaware Agricultural Museum and Village.)

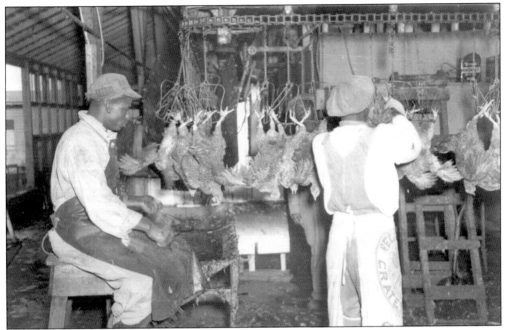

The Eagle Poultry Company in Frankford, started in 1938 by Jack Udell, was the first Sussex County firm to process chickens for shipment. A Russian Jew from New York City, Udell understood the Jewish market in that city. His plant, shown here, became known as the largest in the world. By World War II, a Sussex County man, John S. Isaacs, was a silent partner. Isaacs sold his share in 1949. (Courtesy Delaware Agricultural Museum and Village.)

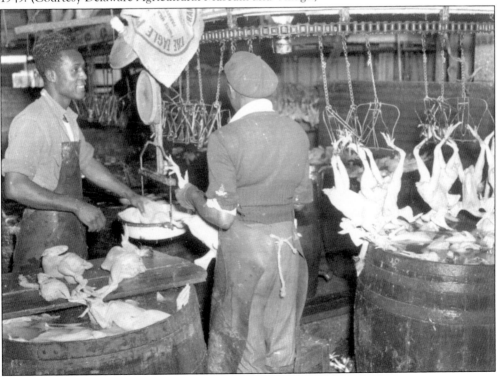

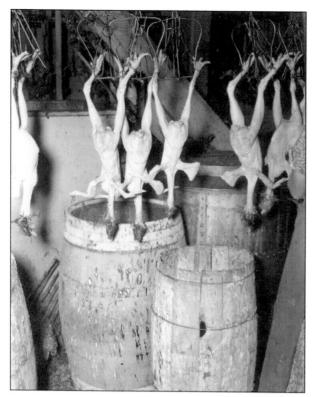

The thin appearance of the birds at left in this 1940s photograph from the Eagle Poultry Plant in Frankford is a far cry from the heavier, bigger birds processed today. The market demand for bigger, plumper birds that could gain more weight in less time stimulated research and development in all areas of poultry science. Below, evaluators grade birds for market characteristics as part of the "Chicken of Tomorrow" contest. This program's goal was to develop a healthier chicken that put on meat more quickly and efficiently than the birds of the past. (Courtesy Delaware Agricultural Museum and Village.)

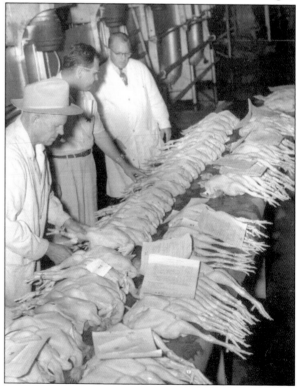

The Delmarva Chicken Festival began in 1949 to celebrate the industry, to bring attention to the "Chicken of Tomorrow" contest, and to conduct the National Chicken Cooking Contest. The festival is still a fixture in Delmarva. At right, Ray Lloyd (lower left) and his colleague put the finishing touches on the sign for the 1955 festival in Georgetown. Below, the Delmarva Festival Parade in 1953 features beauty queens from around the region. (Courtesy Delmarva Agricultural Museum and Village.)

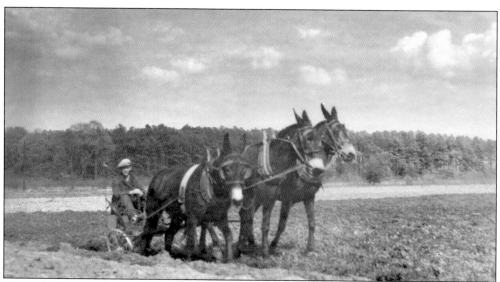

These Sussex County farm scenes from the 1930s represent the end of an era as the forces of science, technology, and a consumer-driven economy begin to transform agriculture with World War II and the dramatic advances that characterized agriculture during the last half of the 20th century. These men would see pesticides that controlled weeds, insects, and diseases; the routine use of manufactured fertilized that dramatically increased crop yields; a highly mechanized agriculture; and a genetic revolution in crop and livestock production. Many of these changes were introduced by the land grant universities and the Cooperative Extension Service. (Courtesy University of Delaware Special Collections: Willard Stewart Collection.)

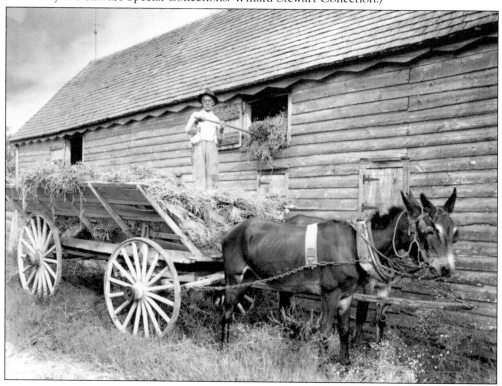

Five

THE UNIVERSITY OF DELAWARE AND FARM ORGANIZATION

George Washington felt that a strong agriculture and a healthy rural society were critical to the national welfare. By 1862, this philosophy manifested itself with the passage of the Morrill Act establishing the Land Grant College System. Delaware College in Newark became our land grant college.

The Hatch Act of 1887 pumped life into an agricultural research system by the establishment of an Agricultural Experiment Station at every land grant college. In 1914, the Smith-Lever Act created Cooperative Extension Service, providing outreach through extension. The first building on the university campus dedicated to agriculture was constructed in 1888 and still stands as Recitation Annex. Wolf Hall housed all agricultural departments until Agricultural Hall (now named Townsend Hall) was built in 1955 on the south campus adjacent to the university farm.

The Farm Bureau and the Delaware State Grange supported the origin and development of the Cooperative Extension System, promoting the concepts and lobbying the state legislature to provide the matching funds to the federal support. Indeed, the first county agents in Delaware were associated the county farm bureaus. As the farm bureaus joined the national farm bureau, which offered goods and services for sale, extension moved totally to the university to maintain its non-biased independence.

In 1914, the first county agents were hired in Delaware. Lee H. Cooch in New Castle County, M. O. Pence in Kent County, and W. C. Pelton in Sussex County were Delaware's pioneer agents. In 1925, acknowledging the rapid growth of an emerging poultry industry, the university hired its first poultry specialist, Hoke Palmer. Soon specialists in entomology, plant pathology, farm management, and an array of other disciplines supported the efforts of the county agents at the local level.

In 1941, the university purchased the Tyndall Farm west of Georgetown to establish the agricultural experiment "substation" at an off-campus location to better serve the industry in southern Delaware. In 2006, the Elbert N. and Anne V. Carvel Research and Education Center opened as the main office for Cooperative Extension and College Research activities in Sussex County.

The University of Delaware Cooperative Extension Service began educational programs for farmers immediately upon its founding in 1914. Above, a 1915 fruit growers' school was held at the university orchards in Newark. Below, a farmer's educational tour in 1922 visited Sussex County farms. (Courtesy Delaware Agricultural Museum and Village.)

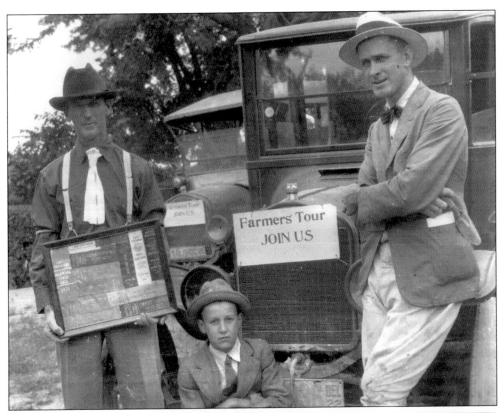

Molloy C. Vaughan, Sussex County agricultural agent, right, holds the sign for his farmer's tour. On the left is Norval Pepper with his son, D. Gooden Pepper. At right, Molloy Vaughan, with his wife, Estelle, accepts an award from J. Frank Gordy in the 1970s. Vaughan left extension, went on to head the State Board of Agriculture, and later entered the commercial turkey business. Gordy, also a Sussex County agent, left a lifetime legacy of service to the farmers of the county and was a guiding force for the poultry industry. (Courtesy Delaware Agricultural Museum and Village.)

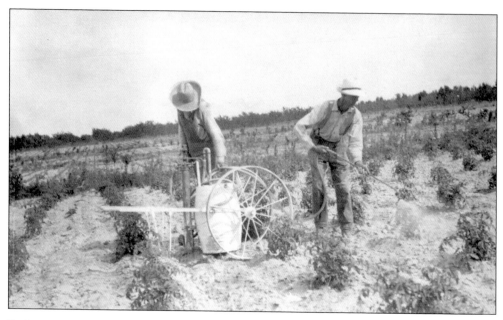

Early county extension agents prepare to spray a tomato disease control demonstration with their portable sprayer in 1916. The wheels detached to allow easy transport in their automobile. Below, the Sussex County agent's educational display at the Kent-Sussex Fair on July 25, 1928, summarized the best corn production practices of the day. (Courtesy Delaware Agricultural Museum and Village.)

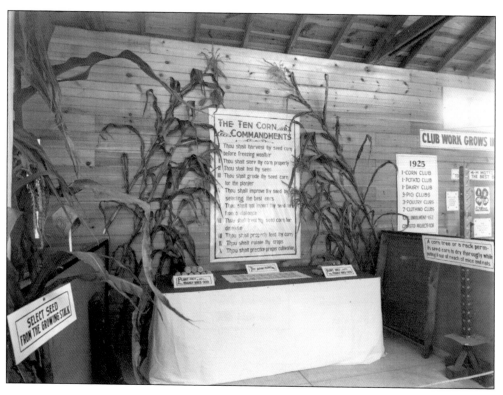

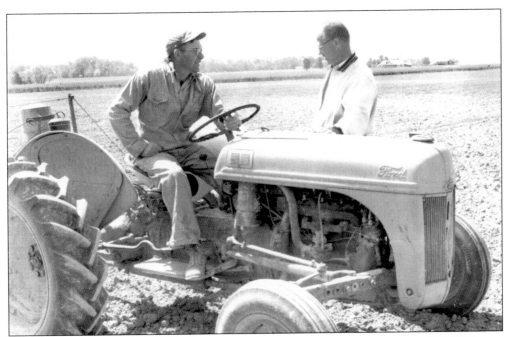

Bill Henderson, Sussex County agent from 1942 to 1978, chats with Frank Dickerson about planting dwarf corn in 1959. Henderson and J. Frank Gordy were institutions in Sussex County. At right, George M. Worrilow is at the microphone during an extension event at the Delaware State Fair in the 1950s. Worrilow began his career as a 4-H agent in New Castle County and rose to become the dean of the College of Agriculture and the director of Cooperative Extension. Worrilow touched thousands of Delawareans. He is especially remembered for encouraging and supporting many farm children to continue their education at the university. (Courtesy Delaware Agricultural Museum and Village.)

In 1941, the University of Delaware purchased the Tyndall farm west of Georgetown to develop an agricultural research and education facility. It was a division of the university's Agricultural Experiment Station and was known for years as the "Substation." In 2006, the facility became the Elbert N. and Ann V. Carvel Research and Education Center, in honor of longtime agriculturist and former governor "Bert" Carvel and his wife, Ann. Carvel also served on the university's board of trustees for nearly 40 years. (Courtesy University of Delaware: Carvel Research and Education Center.)

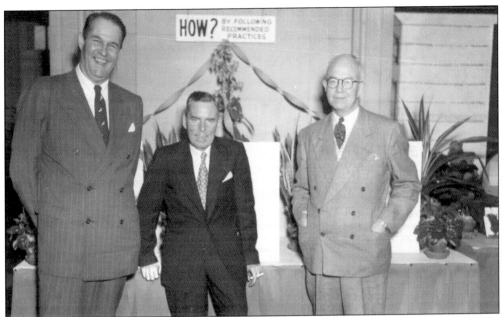

Gov. Bert Carvel (left); George M. Worrilow, dean of the College of Agriculture (center); and an unidentified person pose in 1952 at an agricultural extension function. Carvel married Ann Valliant, whose family owned and operated a fertilizer company that served Delmarva farmers. Carvel ran the company, was elected lieutenant governor in 1944, and was elected governor in 1948 and again in 1960. Worrilow finished his career at the university as the vice president for university relations. (Courtesy Delaware Agricultural Museum and Village.)

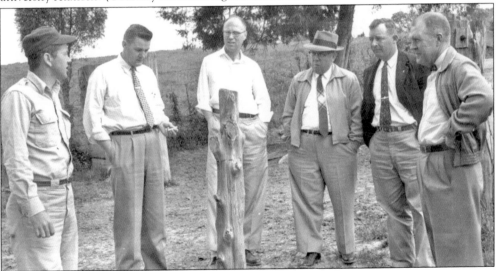

The five men on the right were mainstays of the Cooperative Extension Service for over 30 years. Here they visit a Maryland beef producer on a professional improvement tour. From left to right are the Maryland farmer; Ralph Barwick, assistant Sussex County agent who became dean of instruction at the College of Agriculture; Bill Henderson, Sussex County agent from 1942 to 1978; J. Frank Gordy, Sussex County agent and extension poultry specialist from 1934 to 1972; Ed Schabinger, New Castle County agent from 1952 to 1978; and Ray Lloyd, another Sussex County agent and extension poultry specialist. (Courtesy Delaware Agricultural Museum and Village.)

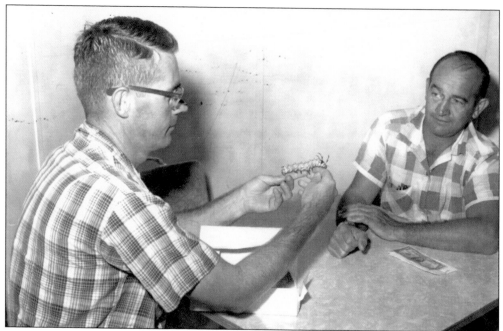

Dr. Dale Bray, chairman of the Department of Entomology and Applied Ecology at the University of Delaware, explains the life cycle of the tomato hornworm to Duane Schierer, an agricultural representative of a tomato processing company in 1958. This type of hands-on, one-on-one consultation is still delivered to farmers. This tradition of extension in Delaware remains an important part of Delaware's agricultural scene. (Courtesy Delaware Agricultural Museum and Village.)

Delaware State University was established in 1890 in Dover as a land grant college for colored students studying agriculture and the mechanical arts. It has grown and evolved from the small college pictured above in the 1920s into an important, fully accredited, and comprehensive university. The university's College of Agriculture and Related Sciences teaches, conducts research, and delivers cooperative extension programs especially targeted to farmers who till less acreage. (Courtesy Delaware Agricultural Museum and Village.)

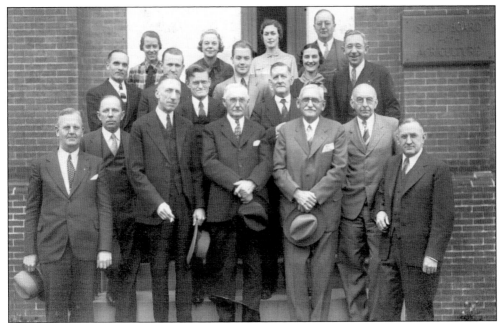

The State Board of Agriculture, pictured here in 1936, operated as the state agency that performed agricultural regulatory and market promotion functions under the old commission form of state government. Since 1969, when the cabinet form of government was established, the Delaware Department of Agriculture performs those functions. From left to right are (first row) Roydon Hammond, Ralph Wilson, Walker Mifflin, O. A. Newton, Newton L. Grubb, Herman H. Hanson, and W. T. Derickson; (second row) J. F. Addams, Wilson Hatfield, Early Dickey, Edward Birmingham, unidentified, Mary Hardcastle, and Robert Sarde; (third row) Evelyn J. Tubbs, Helen Evans, Margaret Maag, and H. R. Baker. (Courtesy Delaware Agricultural Museum and Village.)

Joe Penuel, at the center of the table, chairs a meeting of the state board of directors for the Delaware Farm Bureau in 1961. The Farm Bureau is the major lobbying organization for agriculture in the state. It was also instrumental in supporting the founding of Cooperative Extension in 1914. (Courtesy Delaware Agricultural Museum and Village.)

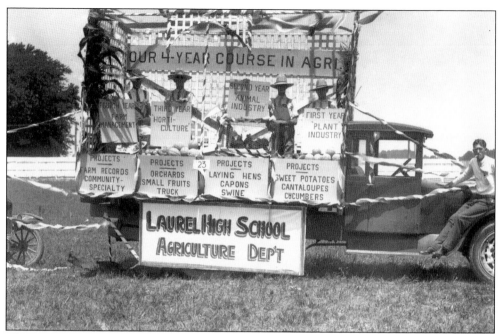

The Future Farmers of America display their curriculum of Laurel High School with this float from the 1920s. The FFA and its allied vocational agricultural programs in the state high schools have provided great training for many Delaware farmers. Below, second from right, is Pennewell "Pen" Isaacs from Lincoln, who was elected secretary of the national FFA. (Courtesy Delaware Agricultural Museum and Village.)

Six

DELAWARE AGRICULTURE TODAY

Delaware today has 2,300 farms that cover 520,000 acres. Forty-two percent of Delaware's land area is in farmland. The largest segment of Delaware's agricultural economy is the broiler industry. Over 282 million broilers are produced annually, generating $844 million of cash receipts.

Soybeans have become the major crop, planted on 184,000 acres, with corn second at 154,000 acres. The corn and soybean crops are sold primarily to the poultry industry for the manufacture of feed. The feed is then distributed back to the farms by the poultry company as part of the contract relationship between the poultry producer and the poultry processing company.

A strong vegetable industry exists on 50,000 acres. Delaware vegetable growers produce potatoes, watermelons, cantaloupes, sweet corn, and other vegetables for the fresh produce market. These crops are sold locally but are also shipped in large, commercial quantities to chain stores and other buyers throughout the eastern United States. Vegetable producers also contract with processors nearly 40,000 acres of vegetable crops to be canned, frozen, or preserved by pickling.

Eighty-five dairy farms operate in Delaware, with 7,400 cows and a state average of 17,716 pounds of milk per cow per year. Beer and pork are also still produced in the state.

An emerging greenhouse, nursery, and turf production industry generates over $34 million in sales annually. Delaware producers seem to be beginning to shift to higher value crops to meet the demand of housing development in this state and throughout the region.

Delaware ranks first in the country in agricultural production value per acre at $1,950. This is a reflection of the income generated by the poultry industry, along with higher value vegetable and nursery crops.

Delaware is losing farmland to development at a rate of over one percent per year. Delaware agriculture may be changing and shrinking, but the poultry/corn/soybean complex, coupled with a diversified agricultural economy, still makes agriculture the largest industry in the state.

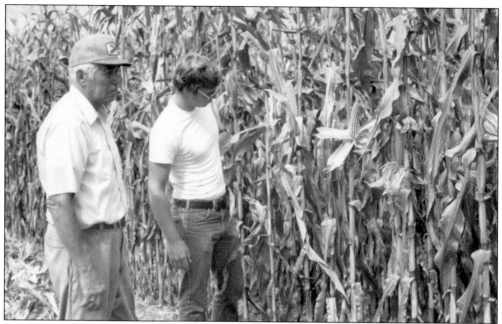

Randall Willin and his son R. C. inspect irrigated corn on their farm near Seaford in the 1970s. It was during this era that center-pivot irrigation came into its own for irrigating field corn. Irrigation, possible with the bountiful aquifers that lie under southern Delaware, helped growers reduce the risk to the crop because of hot, dry weather during the summer. A steady supply of corn is important to the poultry industry as a major ingredient of feed. (Courtesy Delaware Agricultural Museum and Village.)

Soybeans were introduced to Delaware by University of Delaware crop scientists in the early 1900s. At first used as a hay and pasture crop, by the 1920s, it was beginning to be used as a source of protein in animal feeds. Today it is an important part of poultry feed and is Delaware's most widely planted crop. The oil is also extracted for cooking purposes and, most recently, as a source for the manufacture of a renewable fuel known as SoyDiesel. (Courtesy Delaware Cooperative Extension.)

Delaware plants more lima beans for processing than any other state in the country. Nearly 13,000 acres are planted annually for freezing. Mechanically harvested by self-propelled pod strippers, only the bean comes out of the field. This scene is of West Farms, a 10,000-acre vegetable and grain operation near Milford. (Courtesy Delaware Cooperative Extension.)

Pickling cucumbers are mechanically harvested in Delaware. Farmers contract the crop with Kenny Produce, Inc., of Bridgeville or with B&G Foods in Hurlock, Maryland. The cucumbers are then preserved by pickling and transformed into all types of pickle products. Vlasic Foods has a major manufacturing plant in Millsboro and is supplied by Kenny Produce, who in turns contracts with the farmers. (Courtesy Delaware Cooperative Extension.)

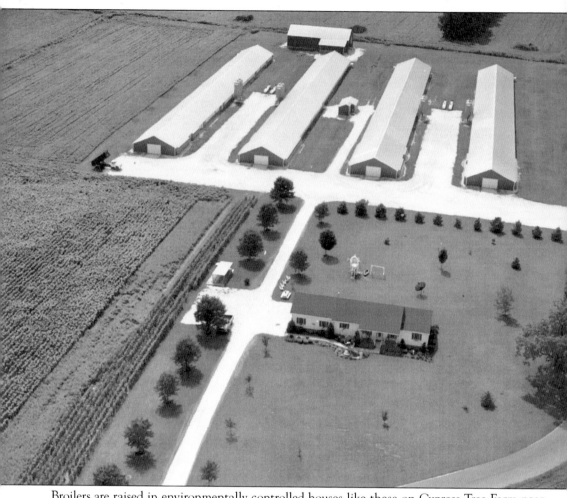

Broilers are raised in environmentally controlled houses like these on Cypress Tree Farm near Gumboro. This scene is 15 miles from the first broiler house of Cecile Steele. Each house contains 25,000 birds and grows between four and five flocks per year. Each flock can reach 4.5 pounds in seven weeks, an amazing testament to the progress of the industry since its beginnings. (Courtesy Bud Malone.)

BIBLIOGRAPHY

Bausman, R. O. *Delaware Farm Production and Prices.* Newark, DE: University of Delaware Agricultural Experiment Station, 1947.

Carter, Richard B. *Clearing New Ground: The Life of John G. Townsend, Jr.* Wilmington, DE: The Delaware Heritage Press, 2001.

Cotnoir, Leo J. *Soils of Delaware.* Newark, DE: University of Delaware Agricultural Experiment Station, 1966.

Eversman, Pauline K., and Kathryn H. Head. *Discover the Winterthur Estate.* Winterthur, DE: The Henry Francis DuPont Winterthur Museum, 1998.

Hoffecker, Carol E., ed. *Readings in Delaware History.* Newark, DE: University of Delaware Press, 1973.

Kee, Ed. *Where Buyer and Seller Meet: Sixty Years of the Laurel Auction Market, 1940 to 2000.* Laurel, DE: The Southern Delaware Truck Growers Association, 2000.

———. *Saving Our Harvest: The History of the Mid-Atlantic Region's Canning and Freezing Industry.* Baltimore: CTI Publications, Inc., 2006.

Munroe, John A. *Colonial Delaware: A History.* New York: KTO Press, 1978.

———. *Delaware: A Student's Guide to Localized History.* New York: Teachers College Press, Columbia University, 1965.

Passmore, Joanne. *Three Centuries of Delaware Agriculture.* Dover, DE: The Delaware State Grange, 1978.

Reed, Henry Clay. *Delaware: A History of the First State.* New York: Lewis Historical Publishing Company, 1947.

"Soil Surveys of New Castle, Kent and Sussex Counties." Washington, DC: USDA Soil Conservation Service and Delaware Agricultural Experiment Station, 1970, 1971, and 1974.

Wilkinson, Norman. *E. I. duPont, Botantiste: The Beginning of a Tradition.* Charlottesville: The University Press of Virginia, 1972.

Williams, William H. *Delmarva's Chicken Industry: 75 Years of Progress.* Georgetown, DE: The Delmarva Poultry Industry, Inc., 1998.

DISCOVER THOUSANDS OF LOCAL HISTORY BOOKS
FEATURING MILLIONS OF VINTAGE IMAGES

Arcadia Publishing, the leading local history publisher in the United States, is committed to making history accessible and meaningful through publishing books that celebrate and preserve the heritage of America's people and places.

Find more books like this at
www.arcadiapublishing.com

Search for your hometown history, your old stomping grounds, and even your favorite sports team.

Consistent with our mission to preserve history on a local level, this book was printed in South Carolina on American-made paper and manufactured entirely in the United States. Products carrying the accredited Forest Stewardship Council (FSC) label are printed on 100 percent FSC-certified paper.

MADE IN THE